WHAT MY DAUGHTER WORE

BY JENNY WILLIAMS

pH powerHouse Books

Brooklyn, NY

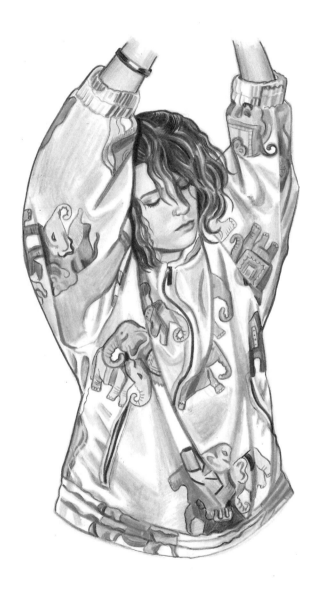

INTRODUCTION BY OLIVIA BEE

One of the perks about being a little girl is that it is entirely socially acceptable to act out every day like it's a new story. Every day a new character will get just about the same kind of warm welcome from parents, teachers, and friends as the character that starred in the story that was the day before.

Having gone through the process of graduating from little girl-dom, I have played my share of characters. There was the little girl that didn't wear anything besides the hats, shoes, and skirts she made from the rhubarb leaves in her mother's garden. There was also the princess, the veterinarian, and the pumpkin. As I grew older and shed my characters' layers in full, I clung onto some of the things that made my young characters tick; a dress covered in fairies in a garden, a Halloween hat, my Curious George backpack, a rhinestone encrusted tiara, a necklace that stated my name, big and bold.

When one begins teetering on this line between little girl and not-so-little girl, pieces of characters-past remain in our hearts as we move on to new roles. This book is about girls in this transitional phase of being just about 12, and discovering in-between characters who take quirks and traits (a particular T-shirt she loves and the way she bites her tongue when she's nervous are equally as important) from their past selves and put them in a new context. It's not about any sort of permanence in fashion or role playing, but rather, it is about saying, "This is who I am today."

For David, Paco, Whitman, and Clementine

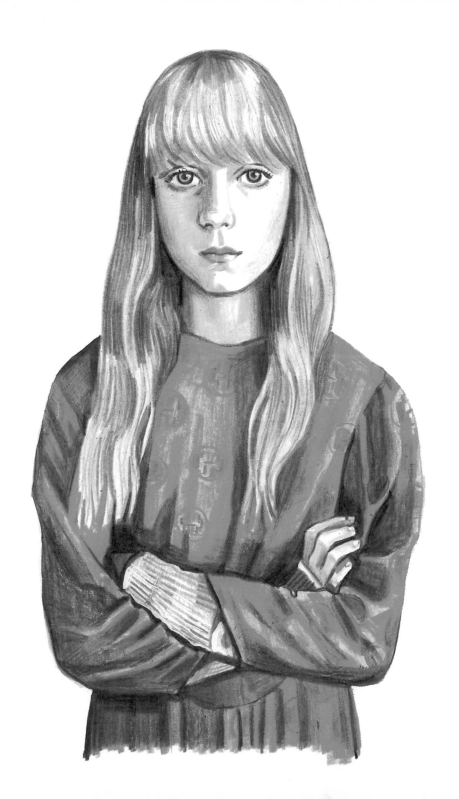

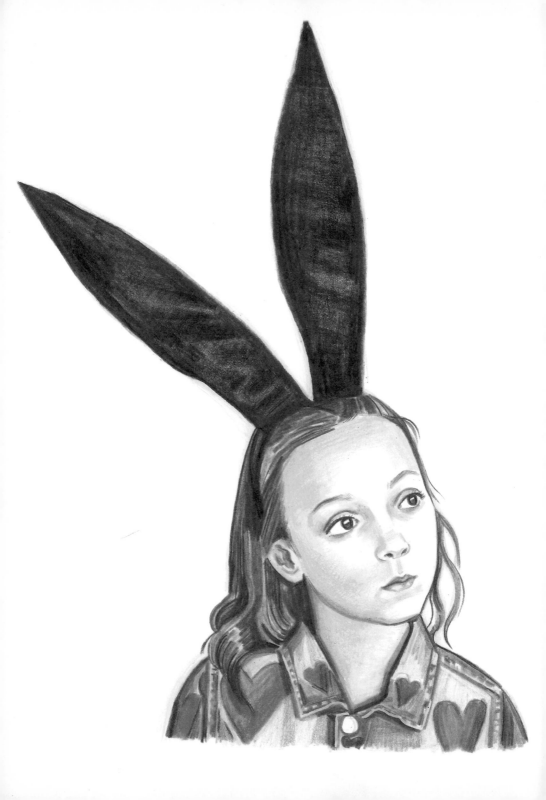

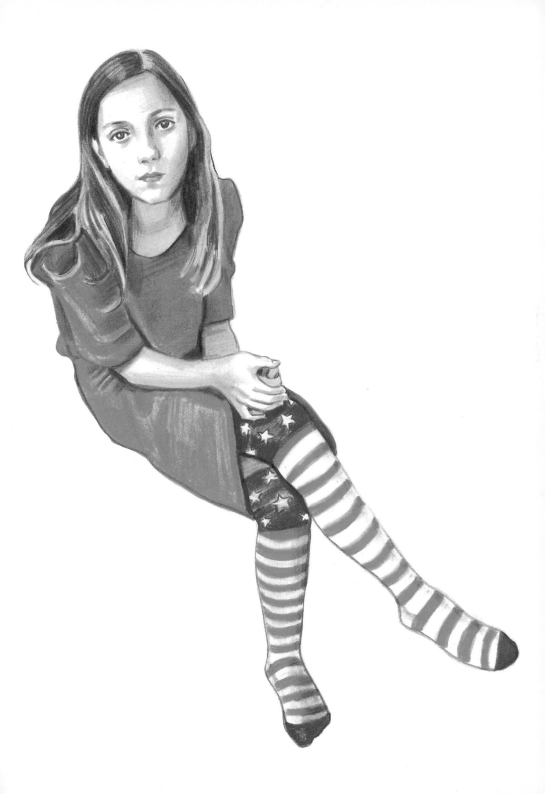

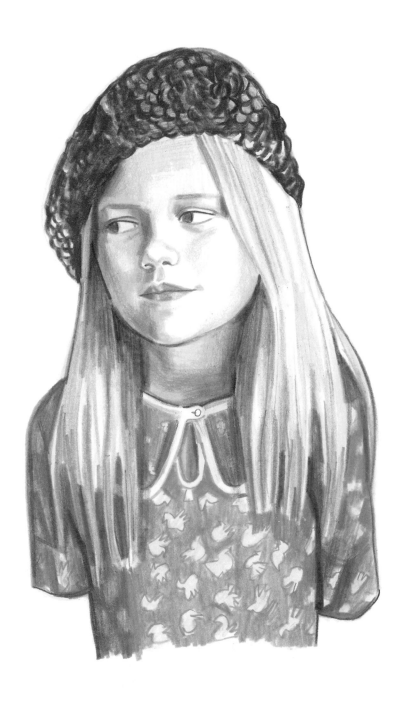

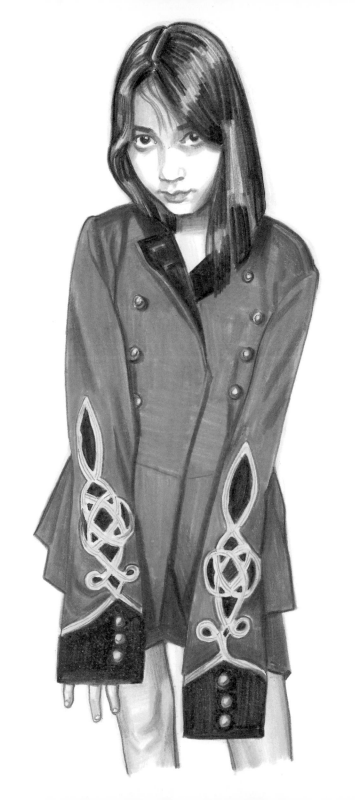

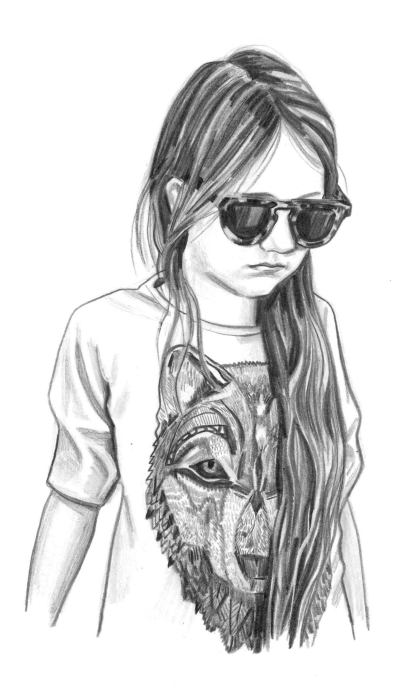

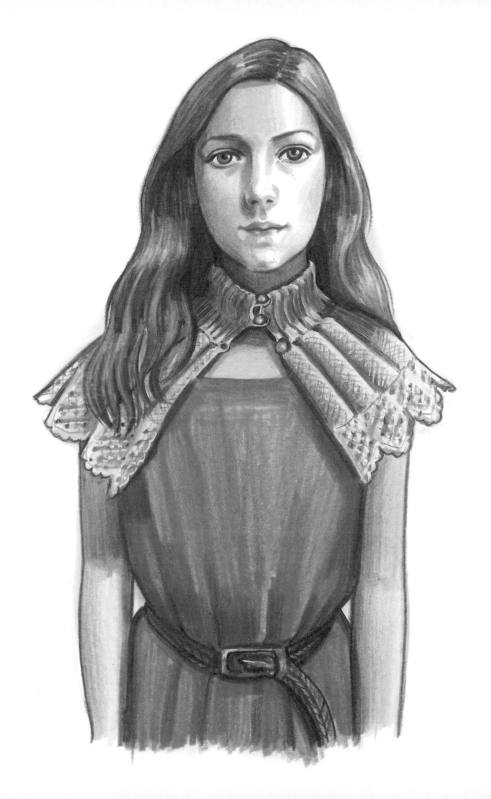

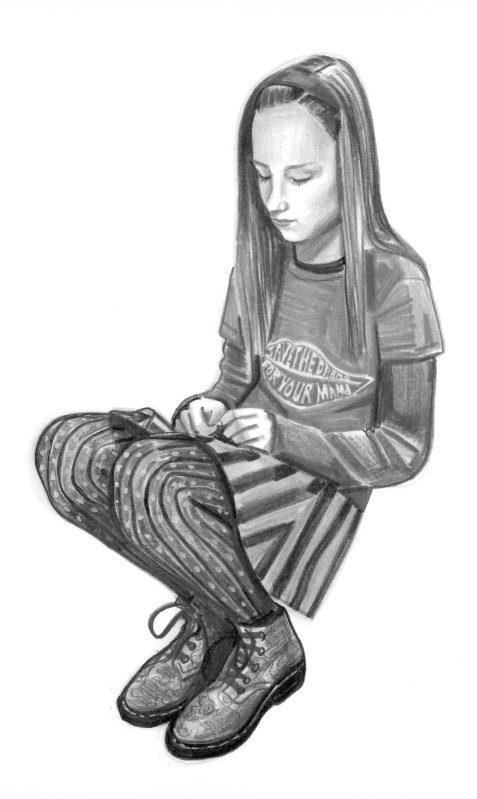

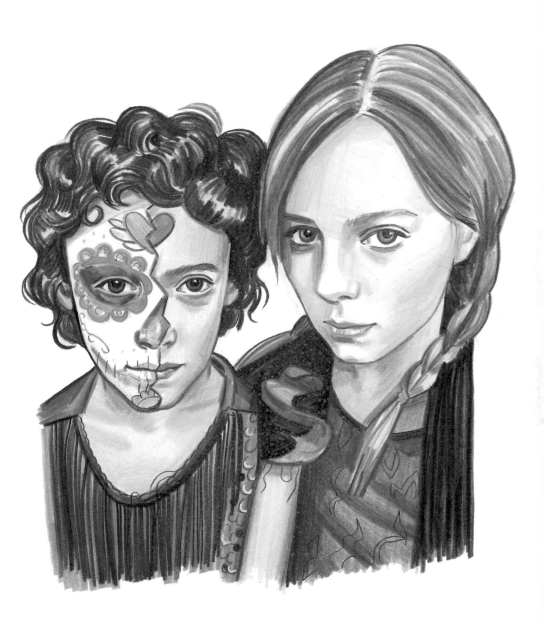

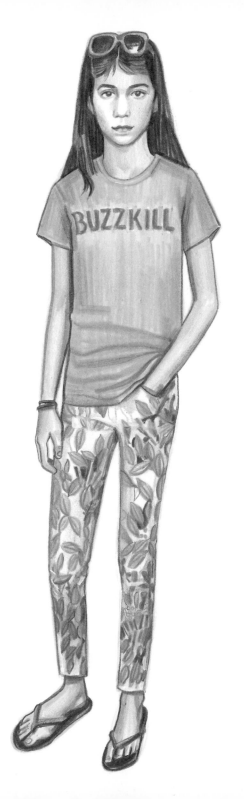

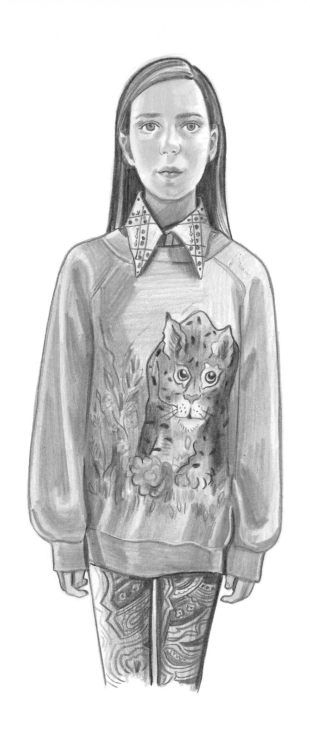

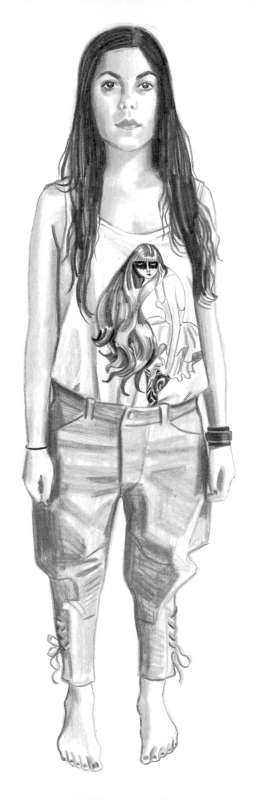

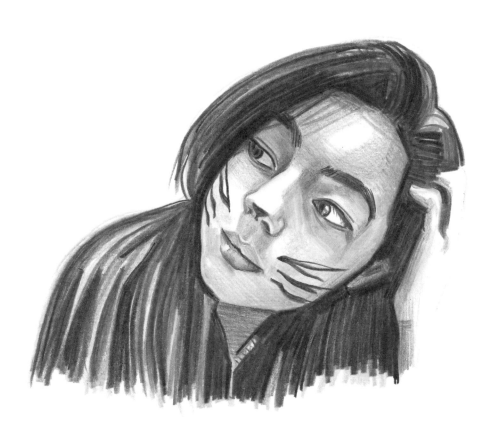

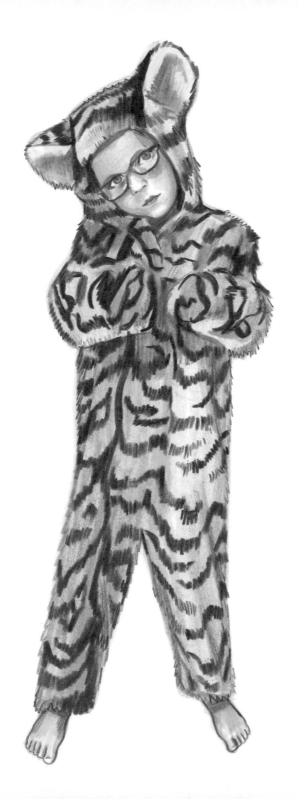

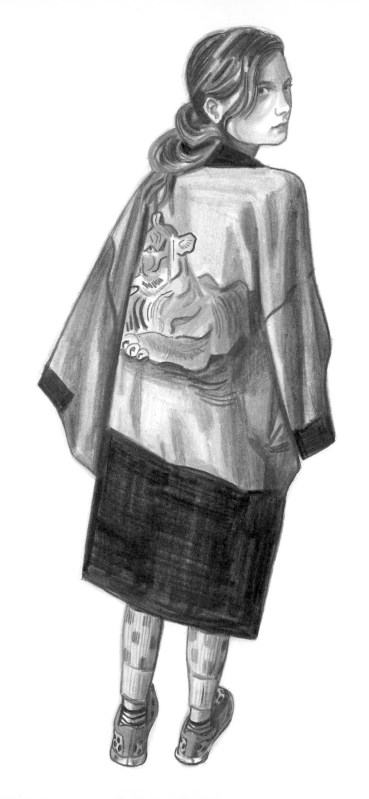

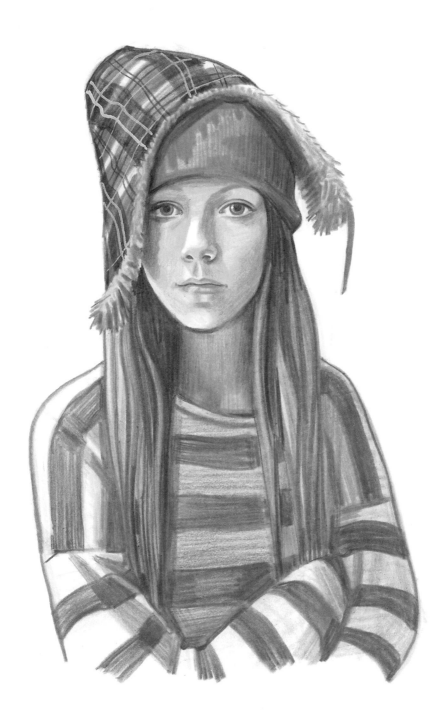

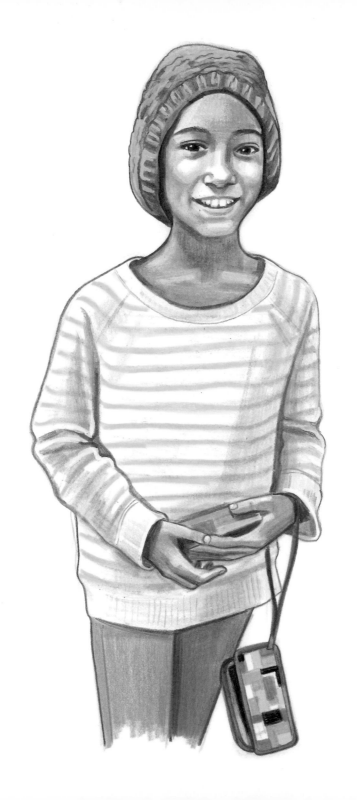

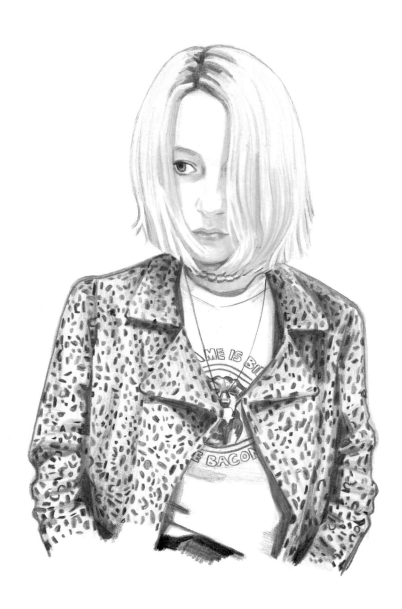

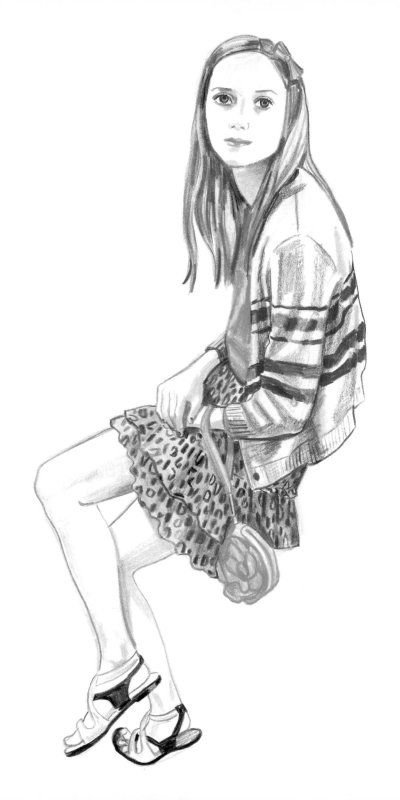

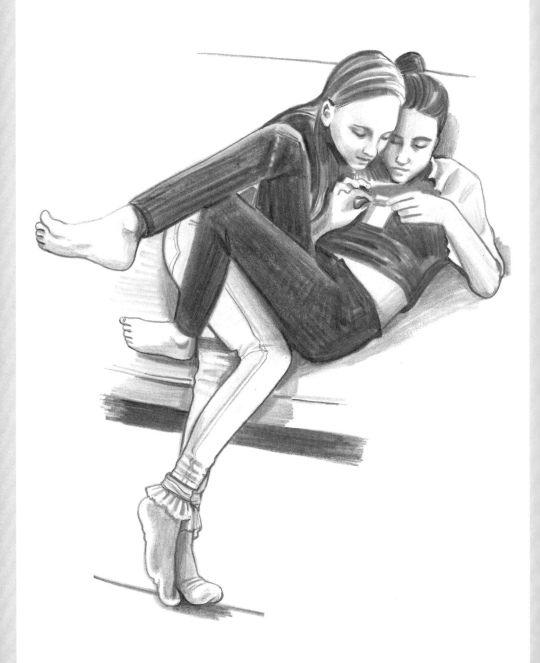

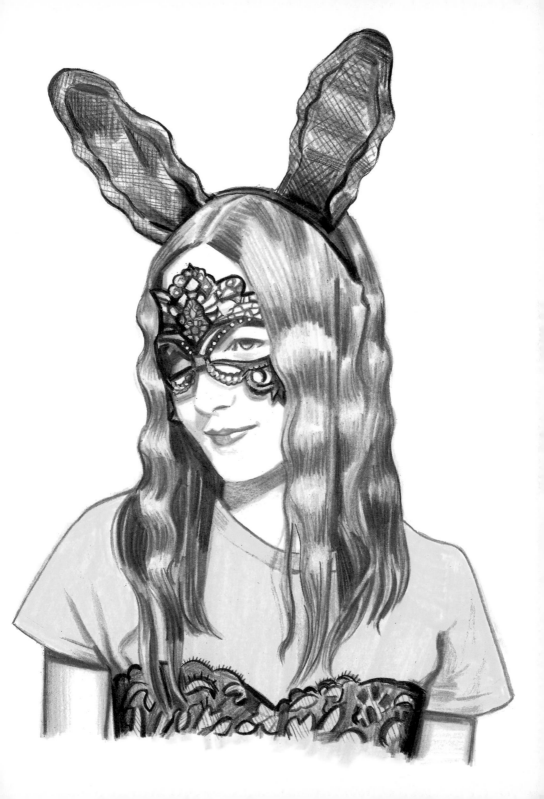

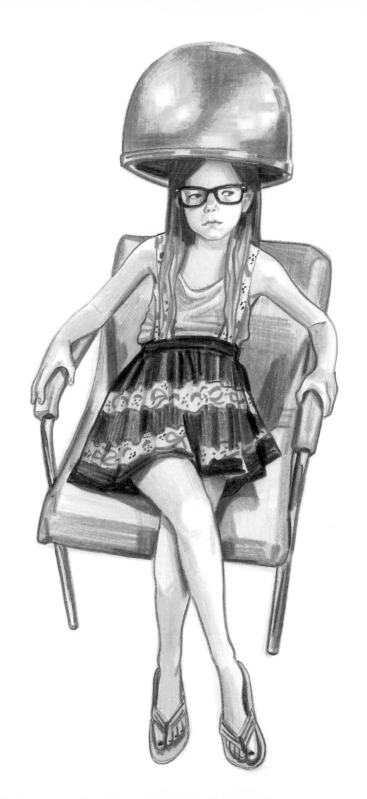

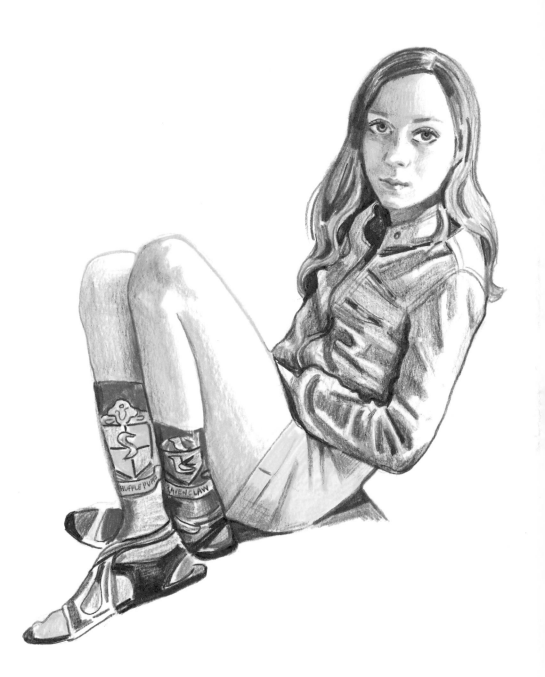

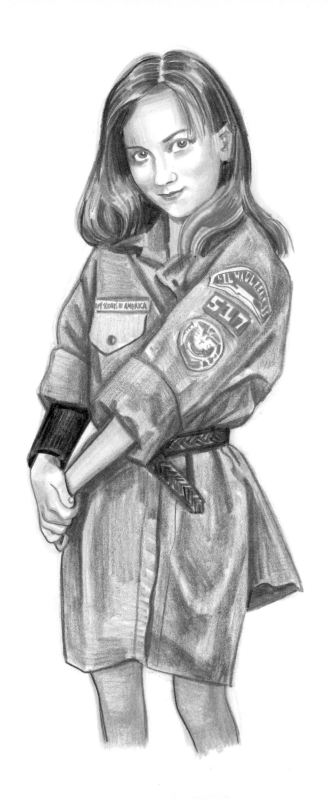

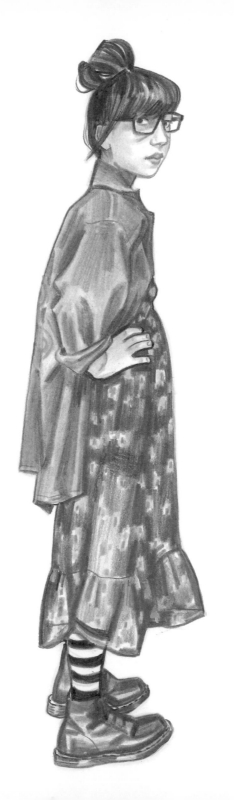

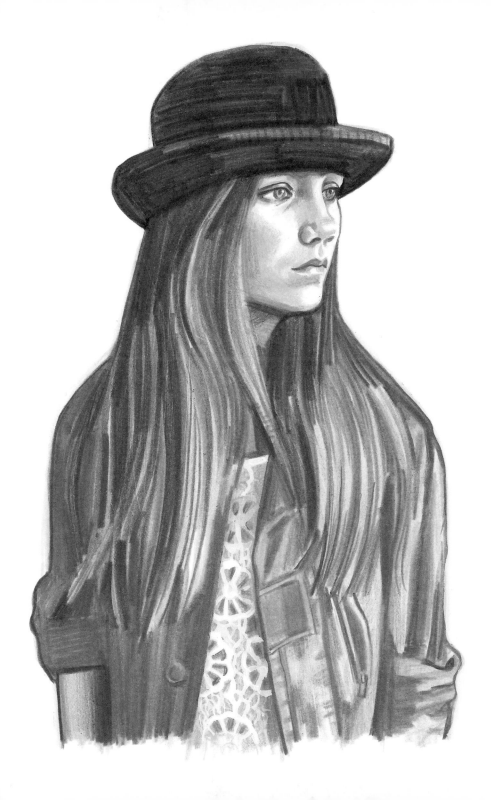

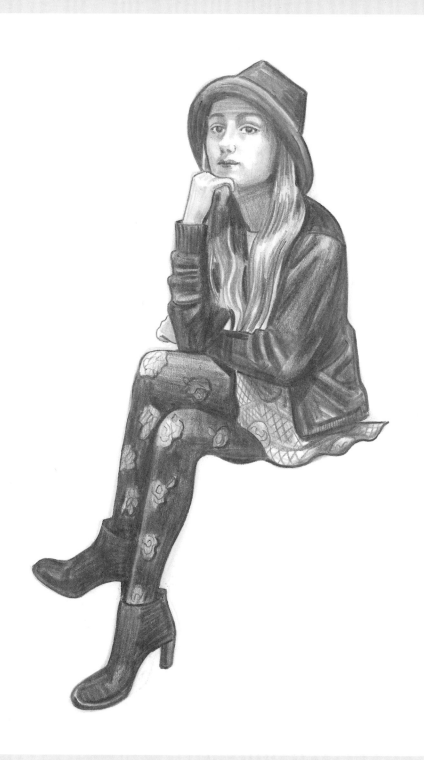

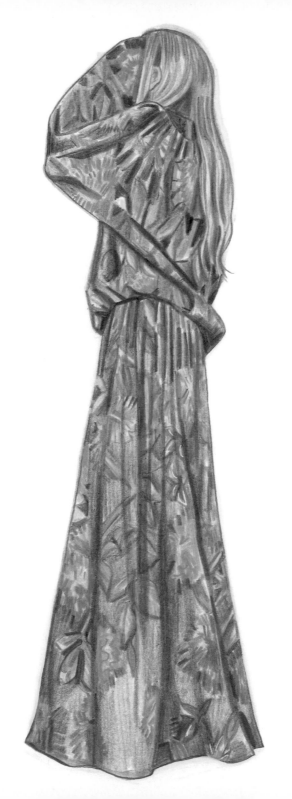

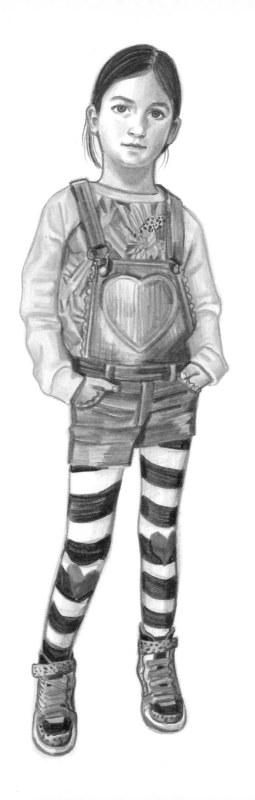

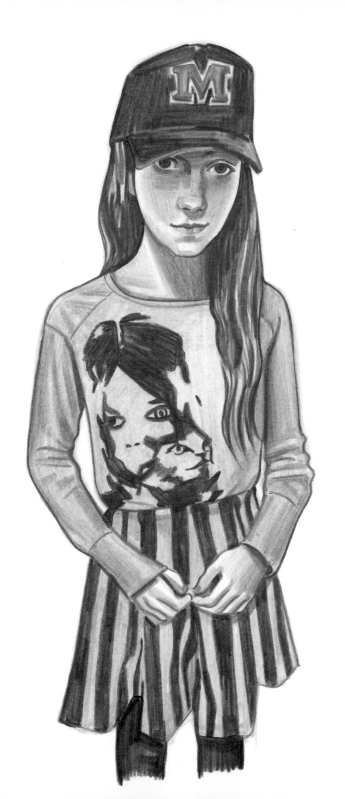

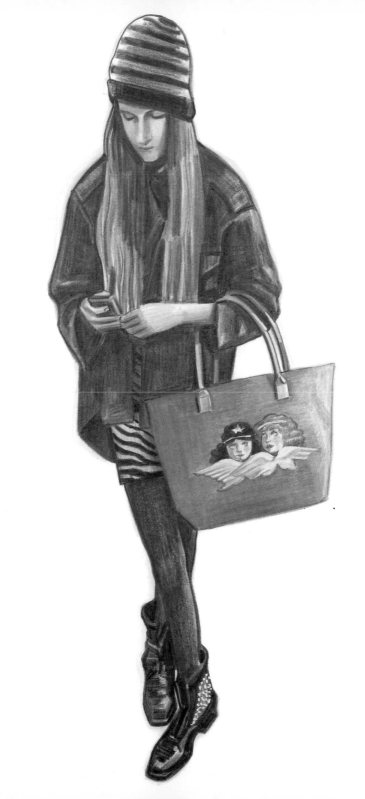

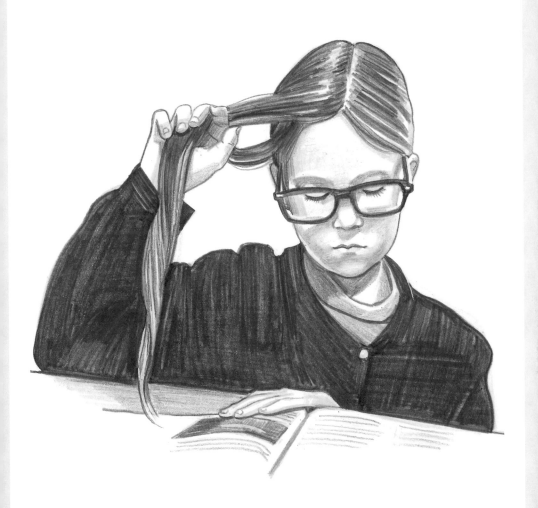

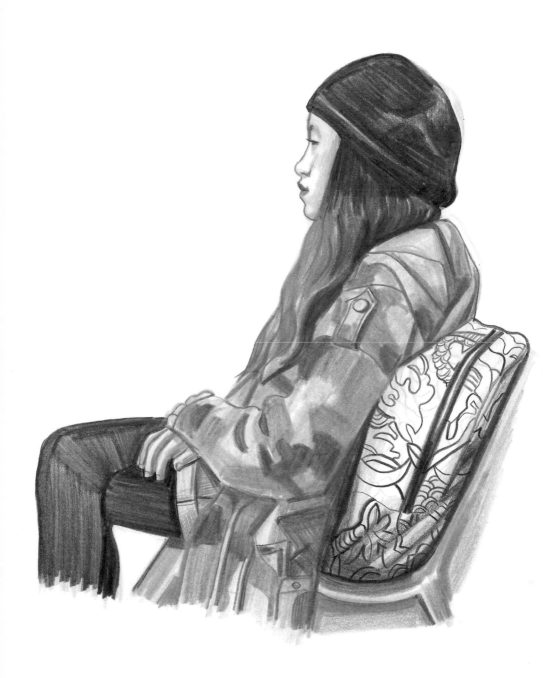

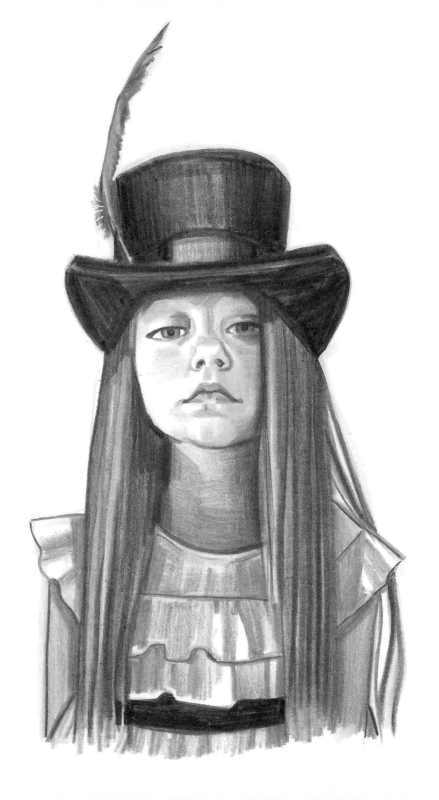

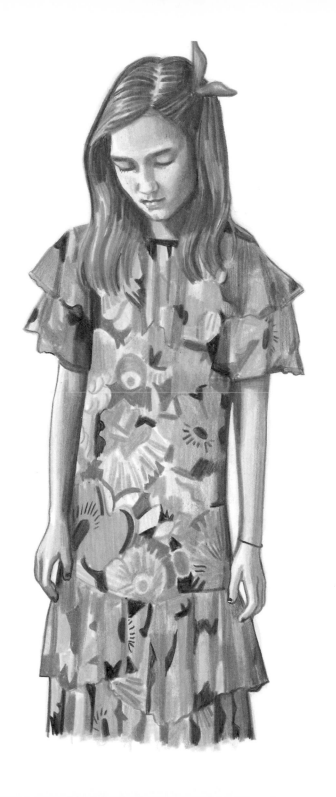

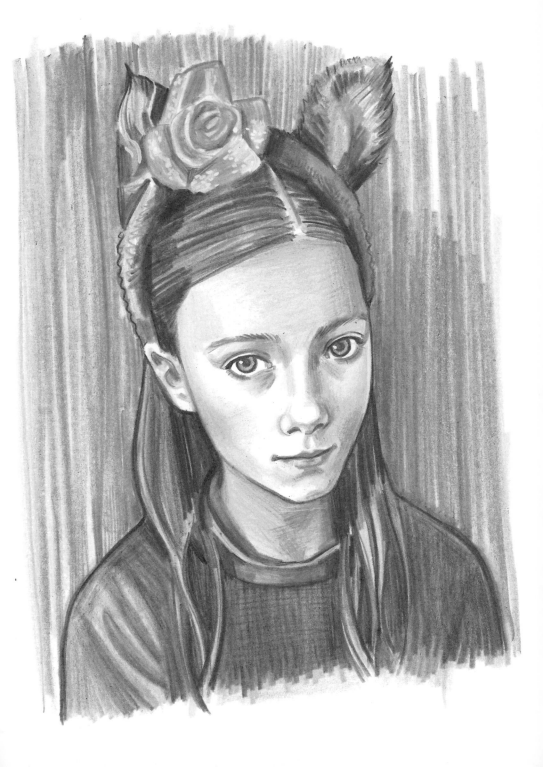

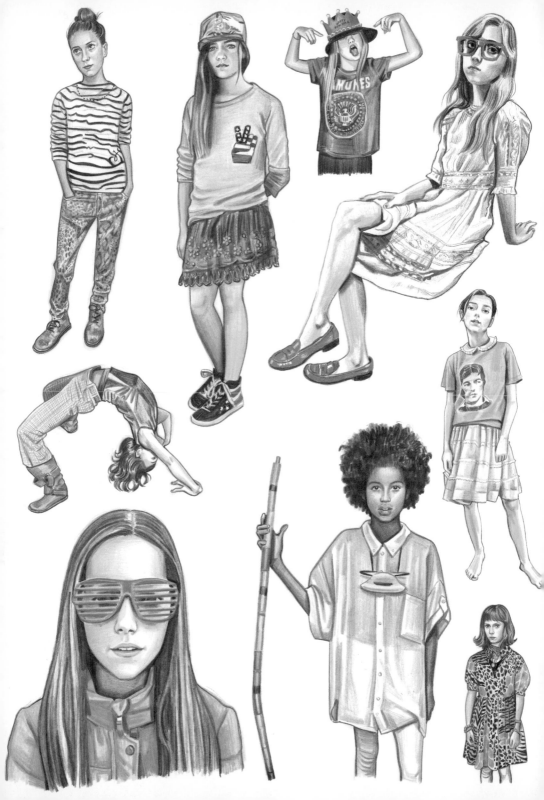

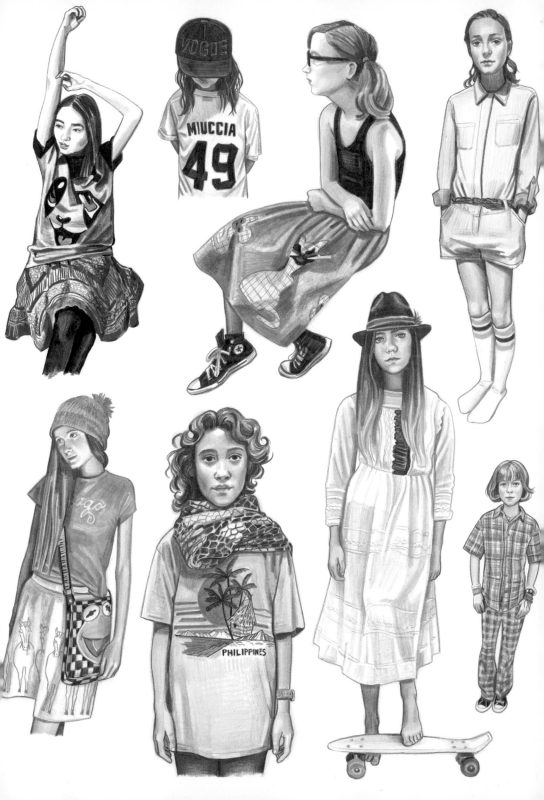

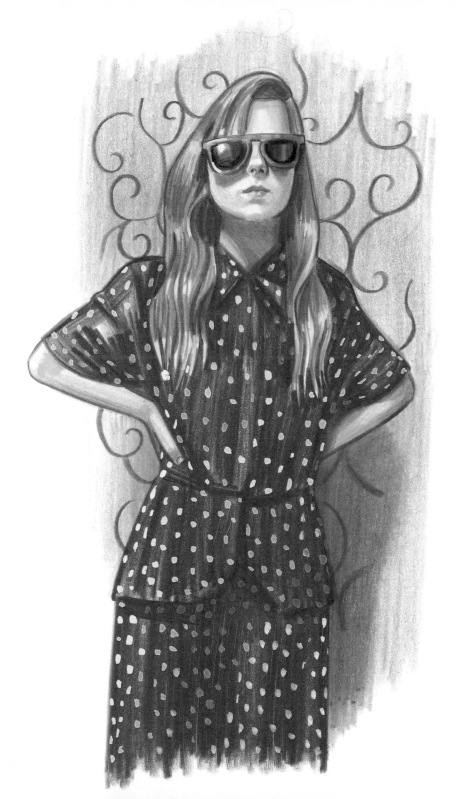

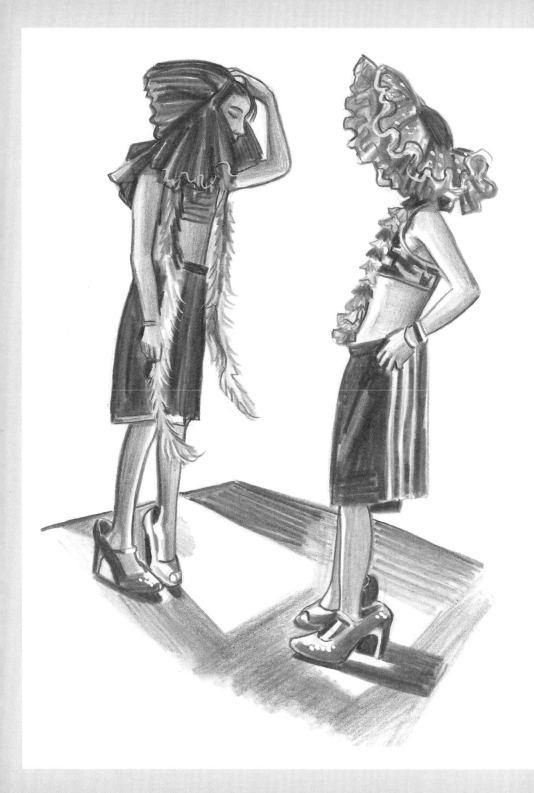

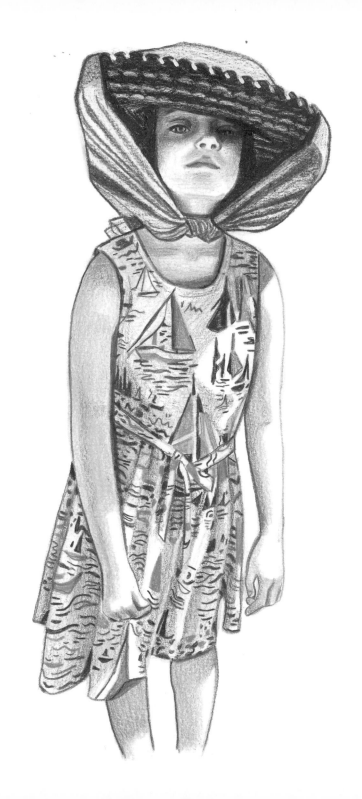

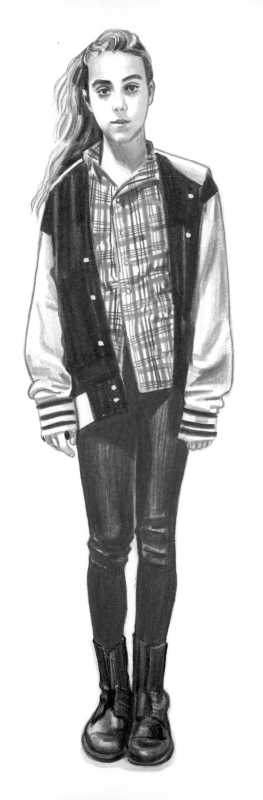

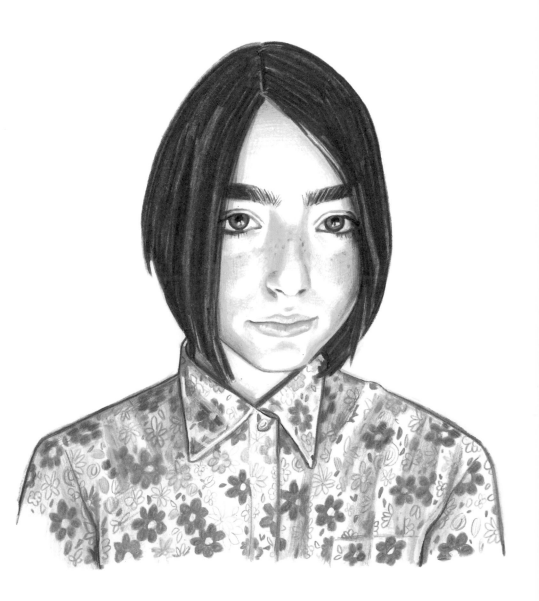

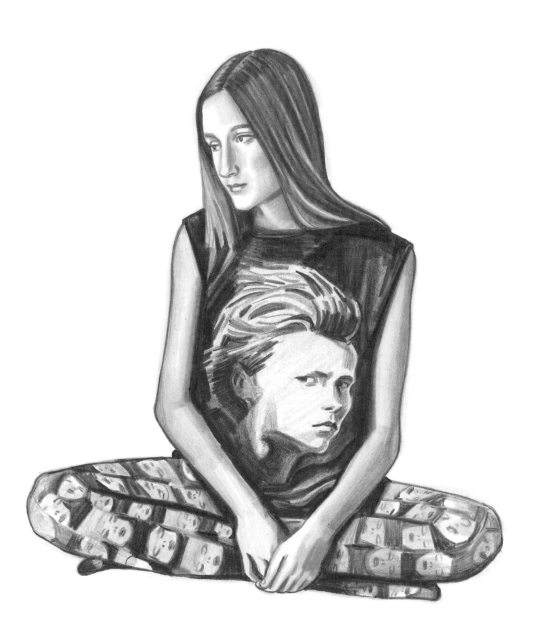

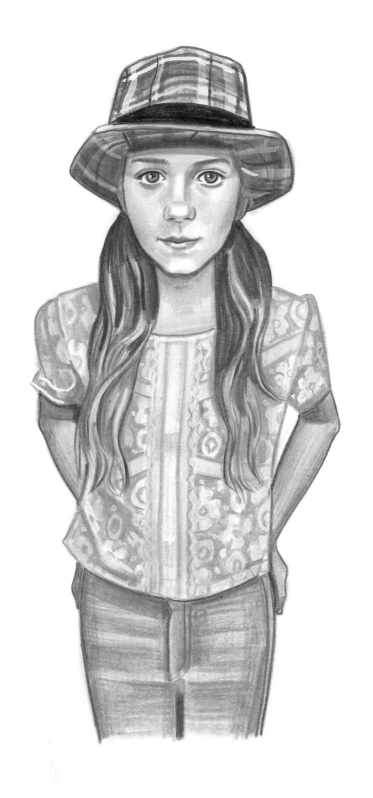

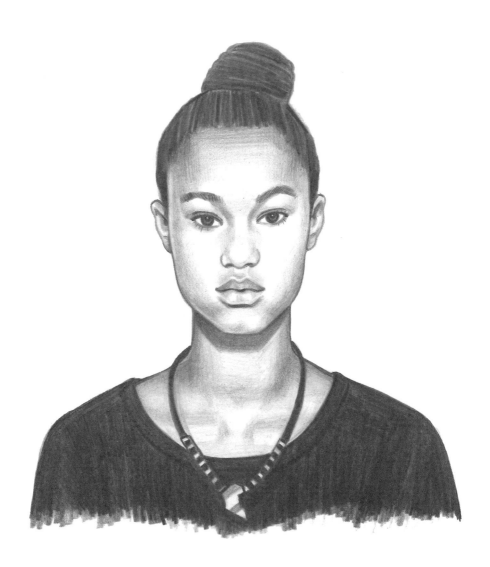

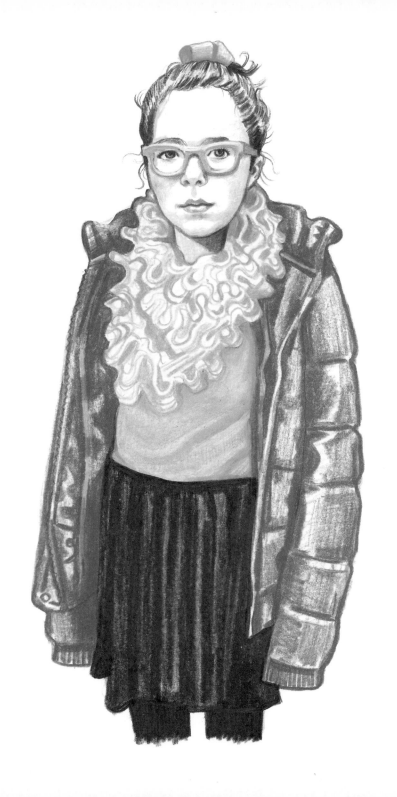

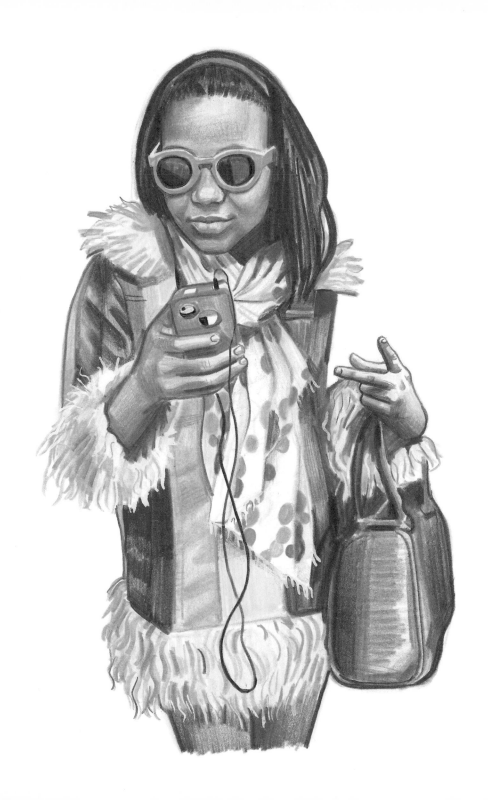

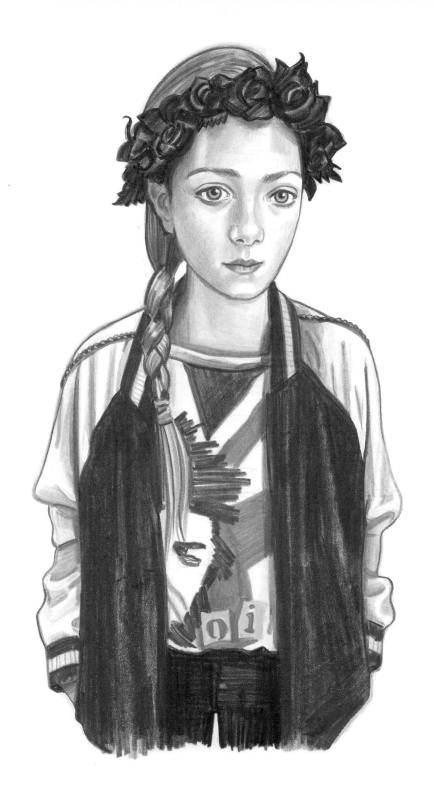

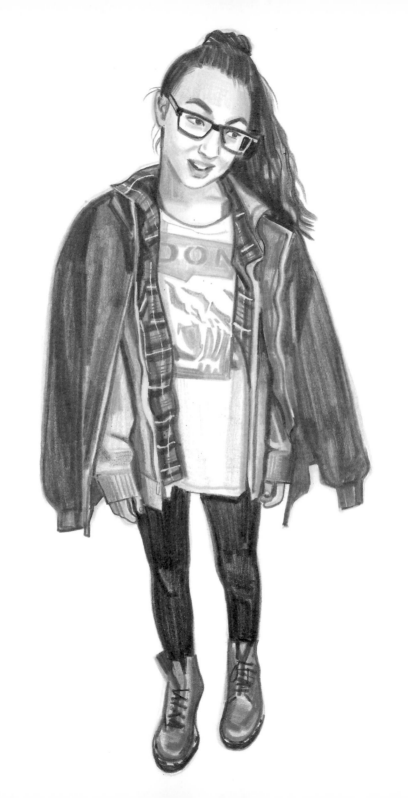

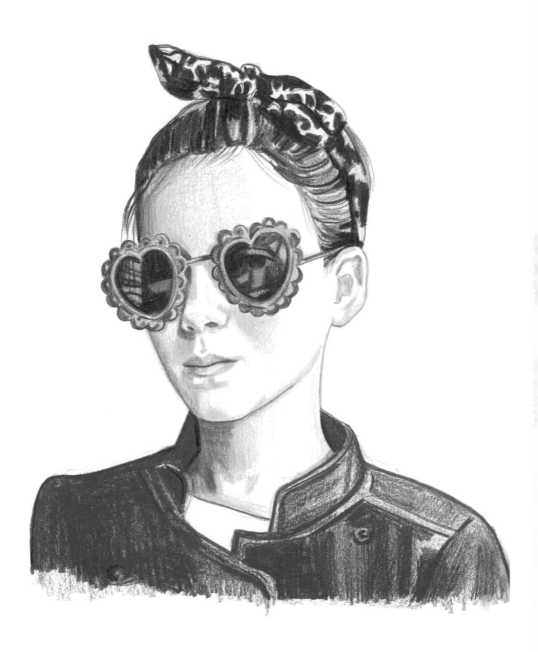

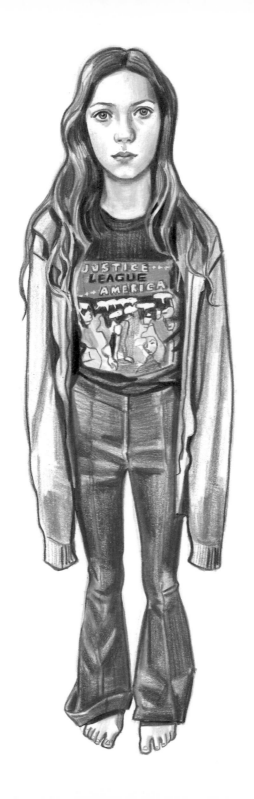

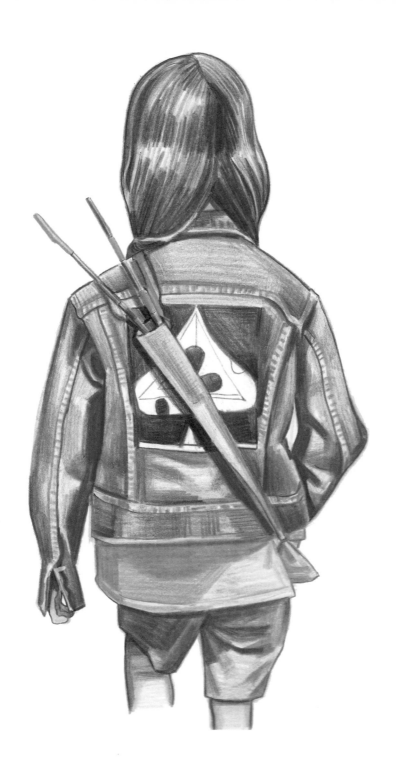

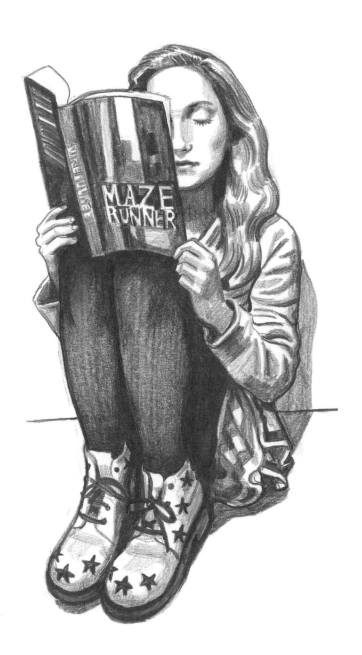

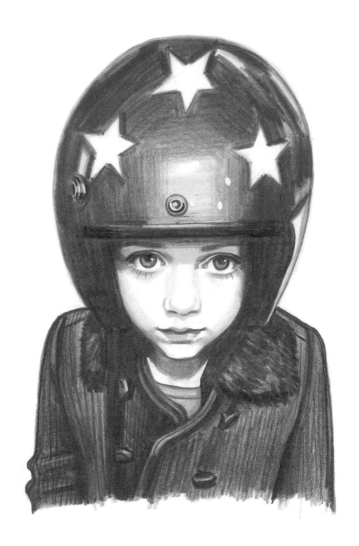

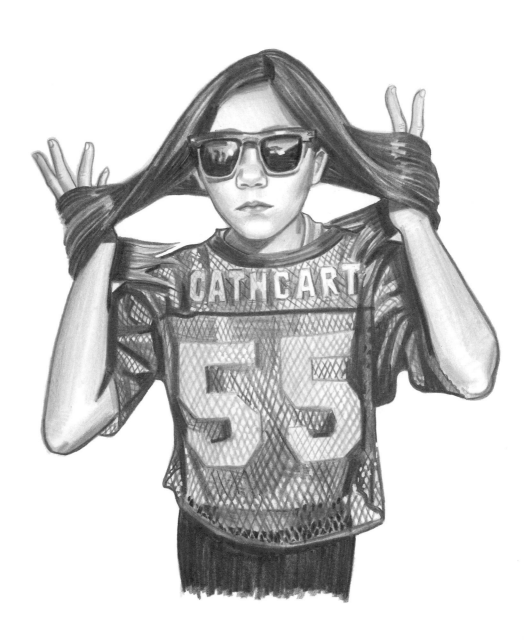

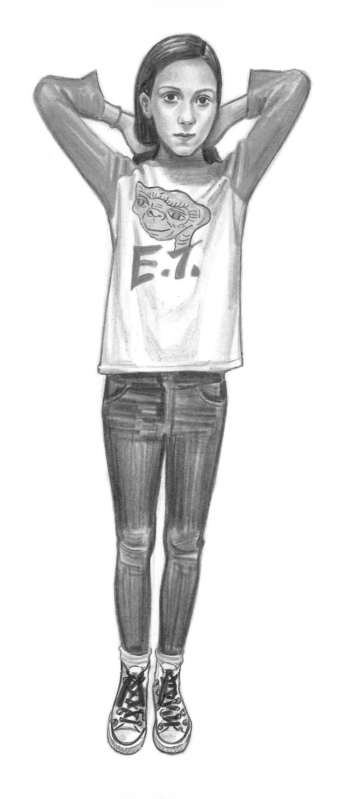

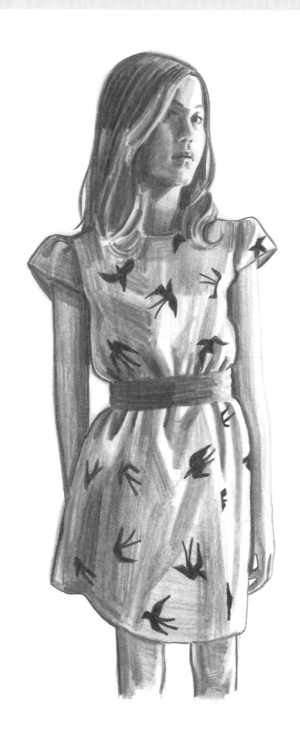

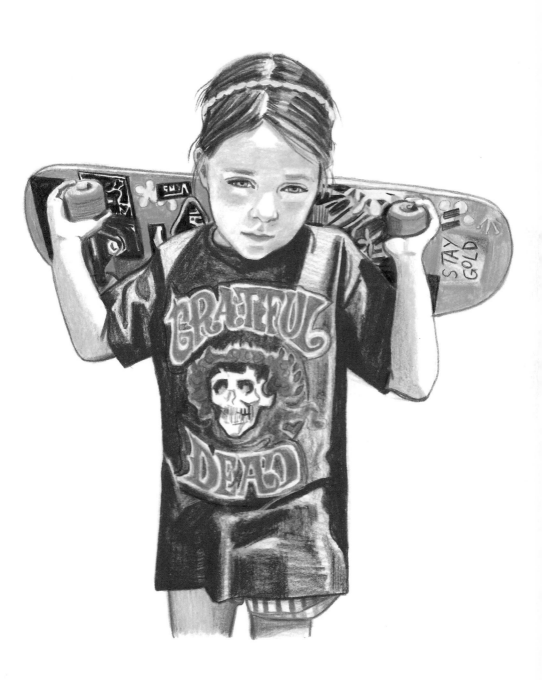

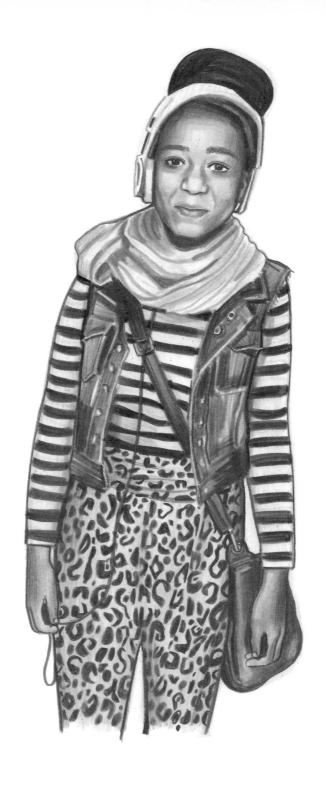

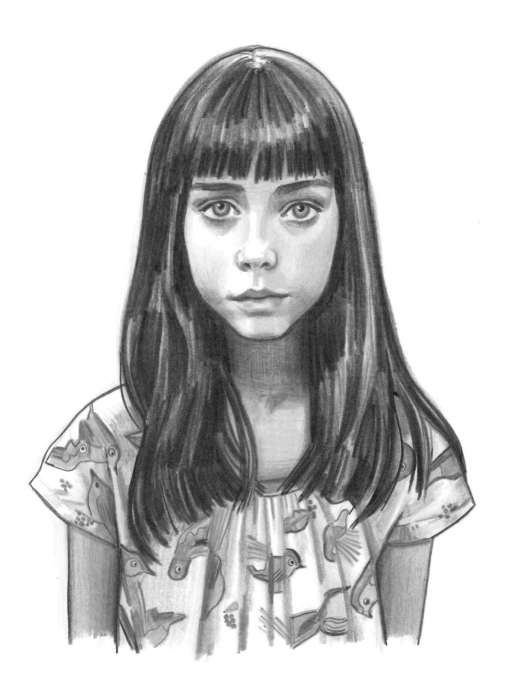

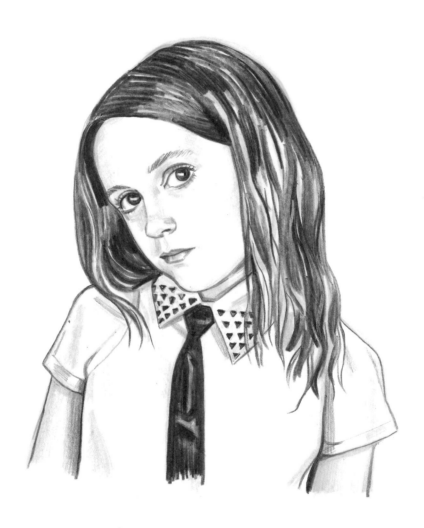

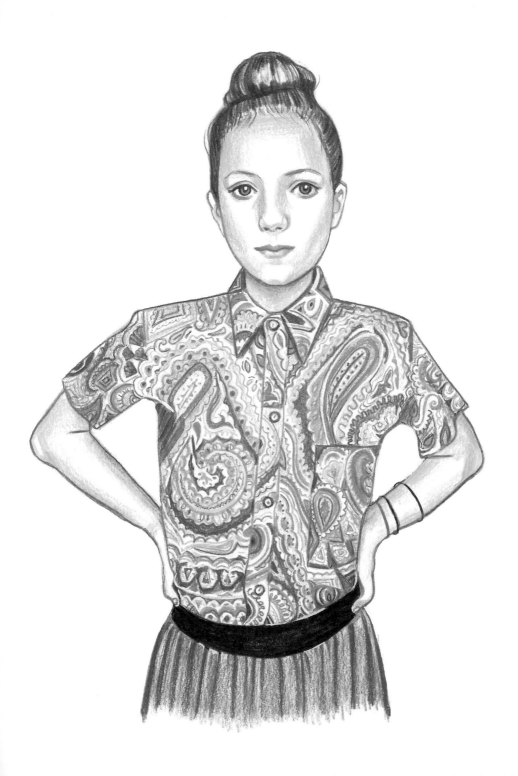

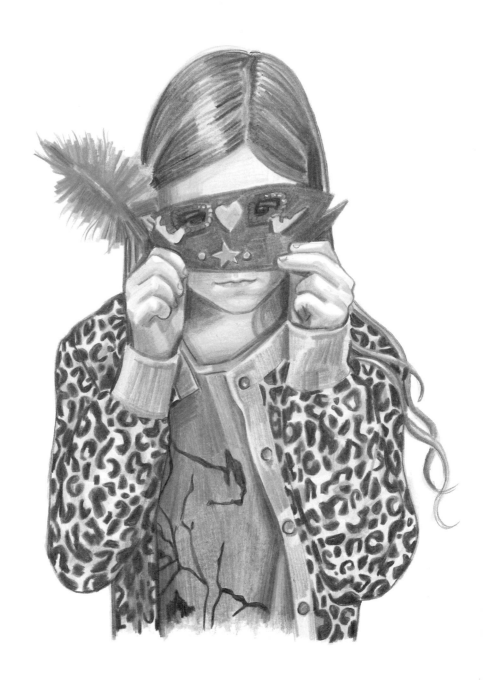

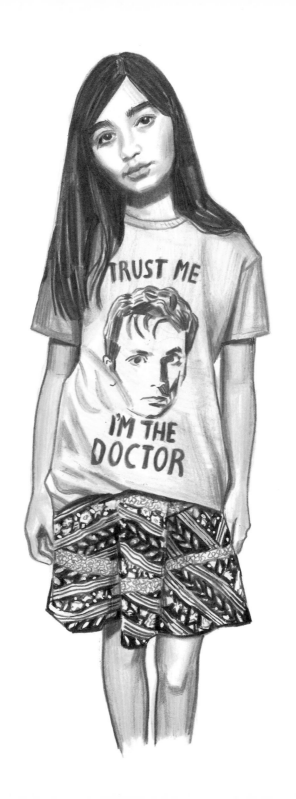

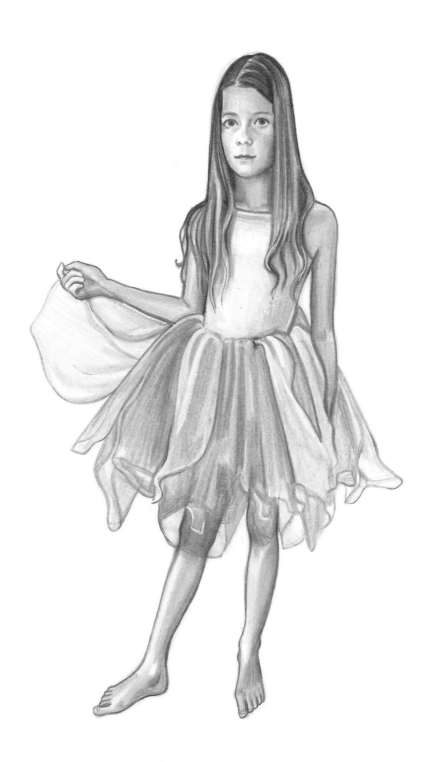

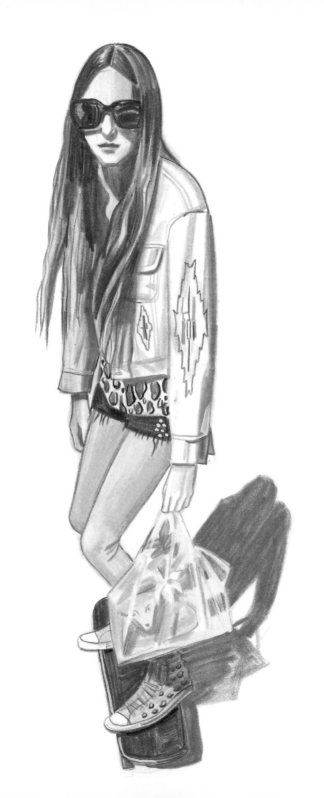

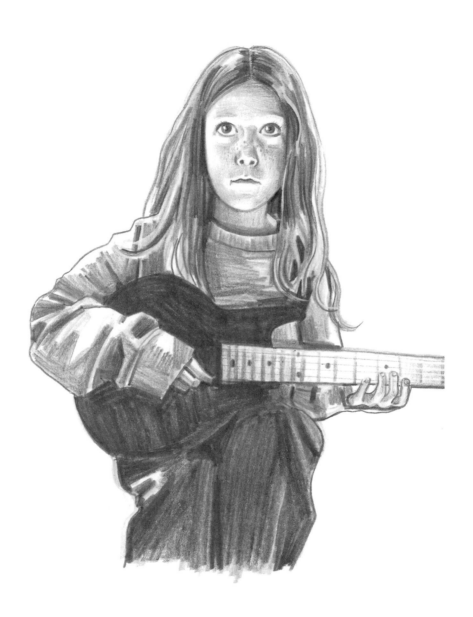

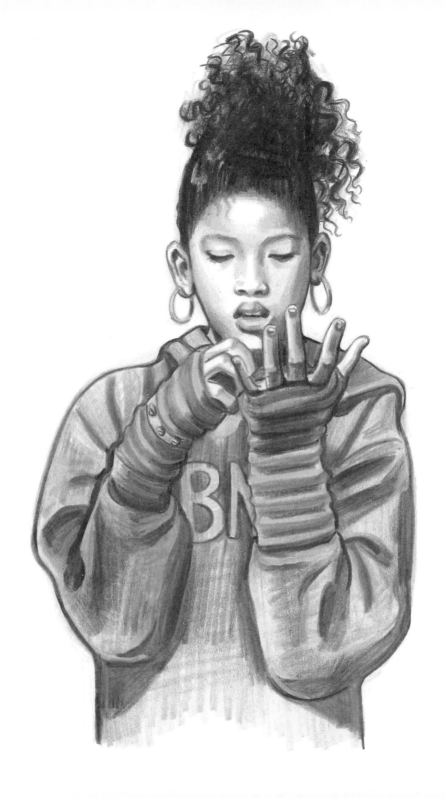

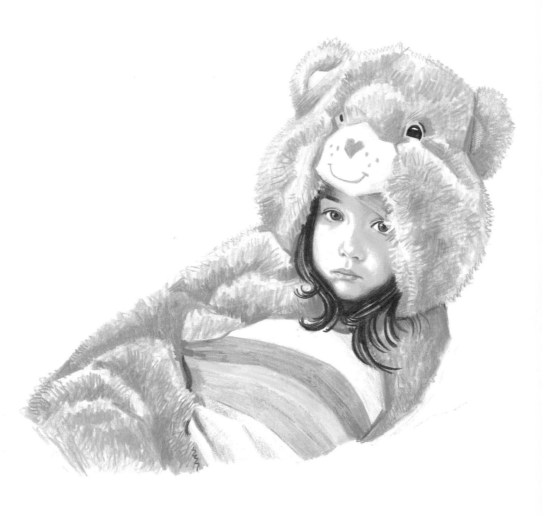

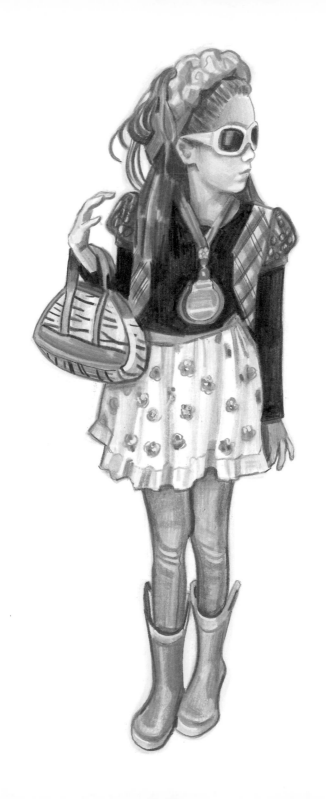

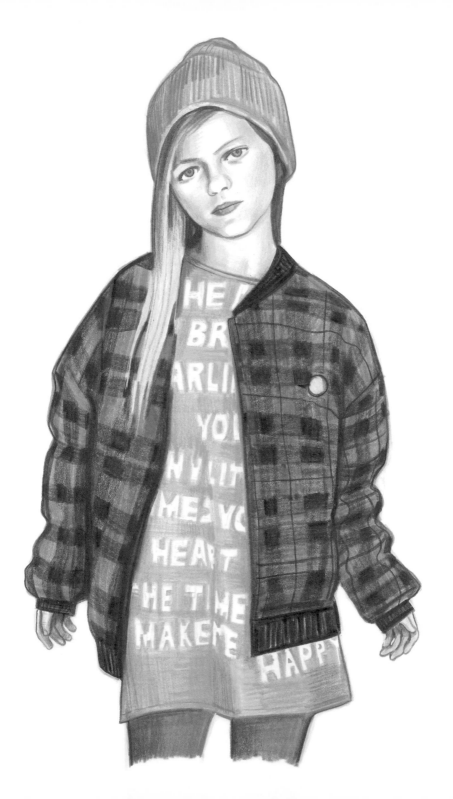

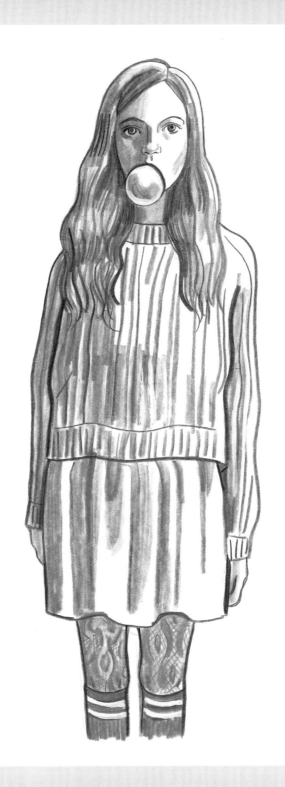

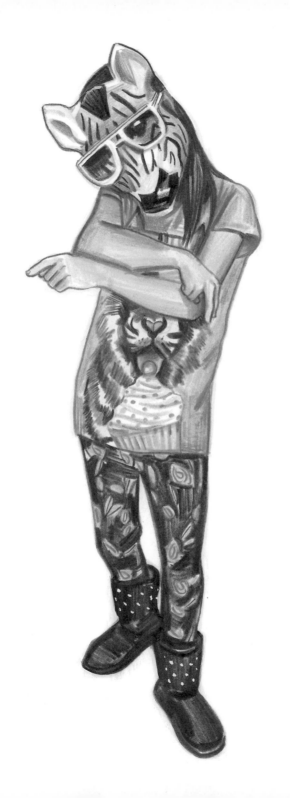

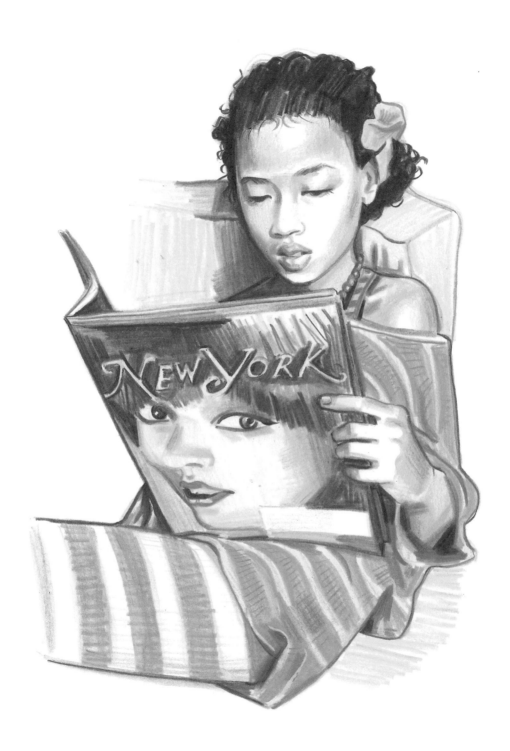

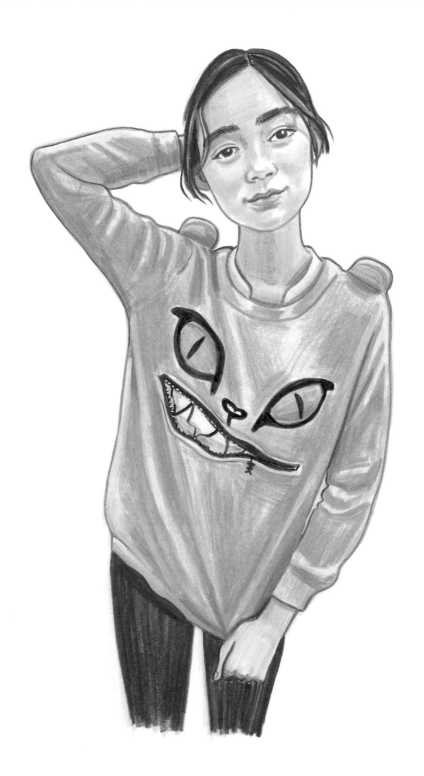

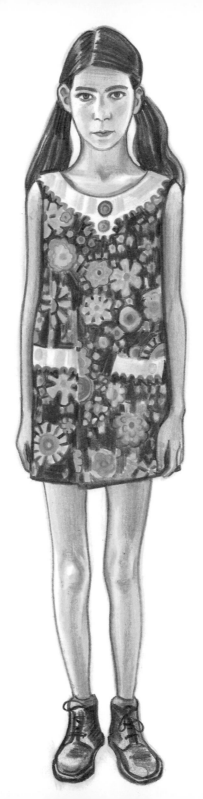

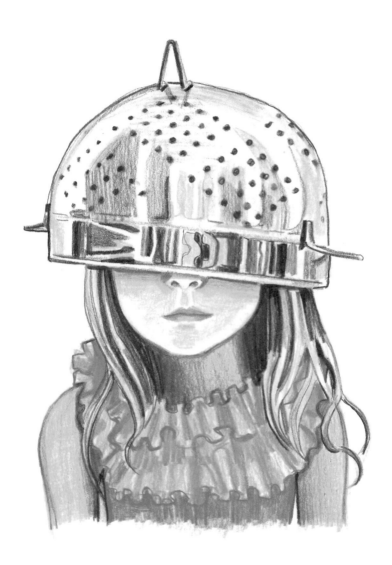

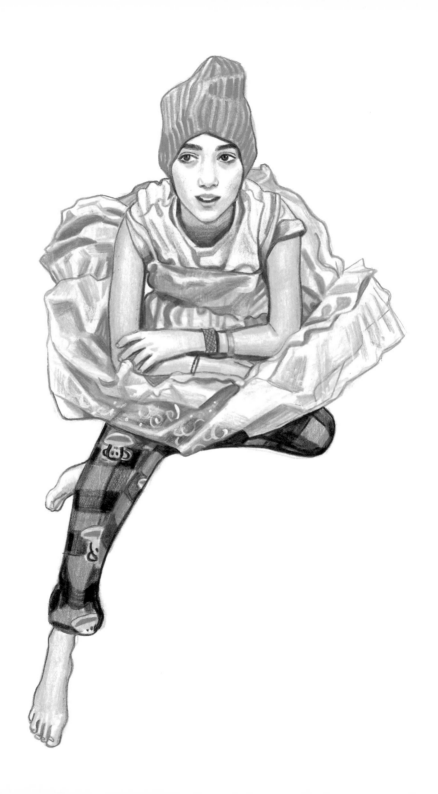

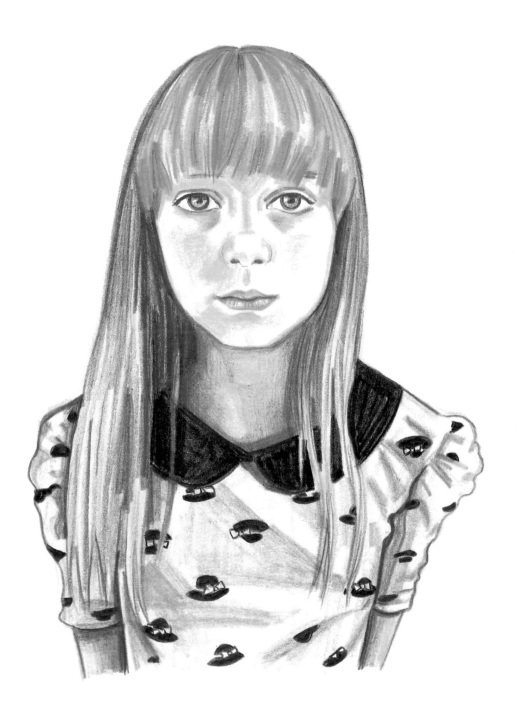

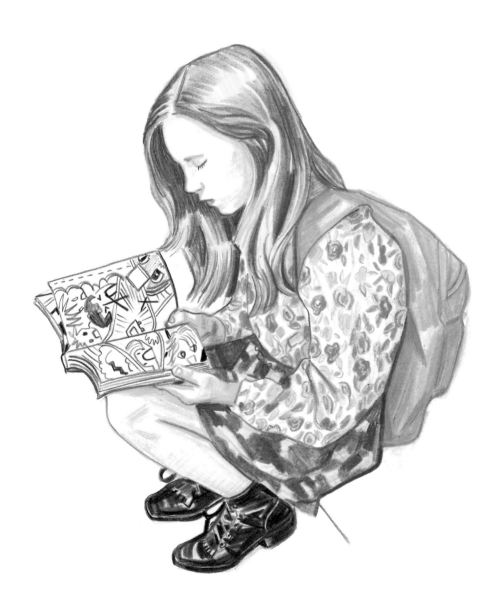

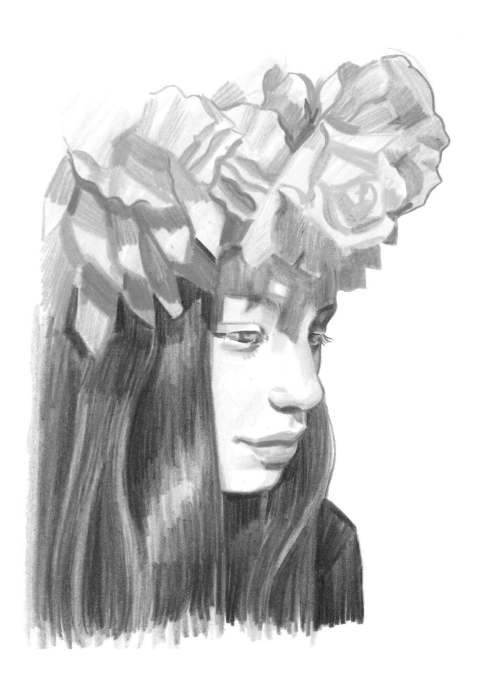

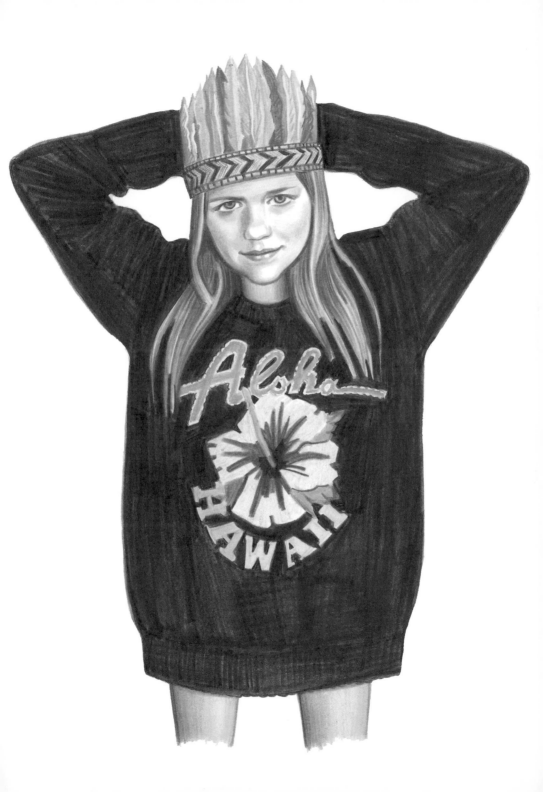

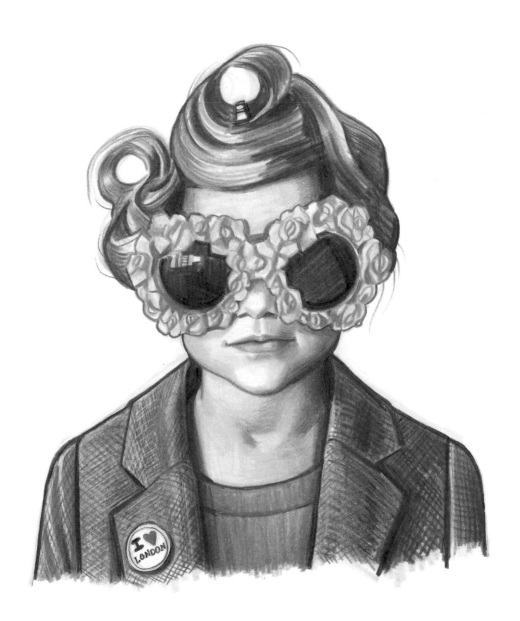

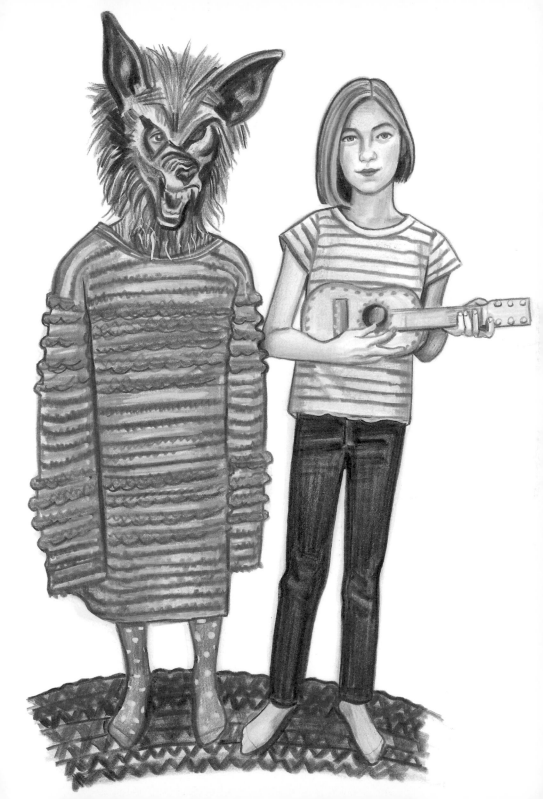

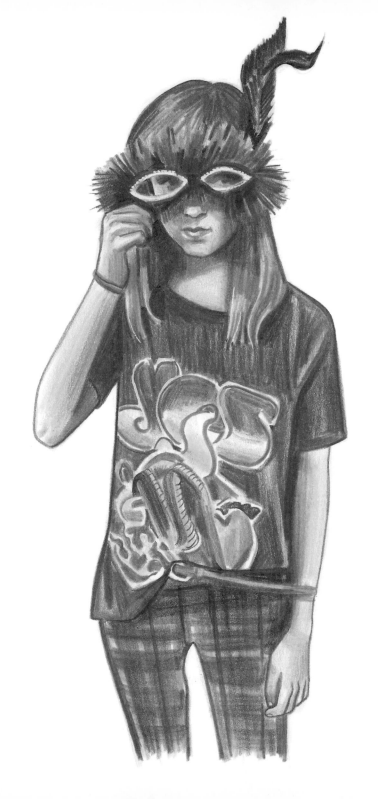

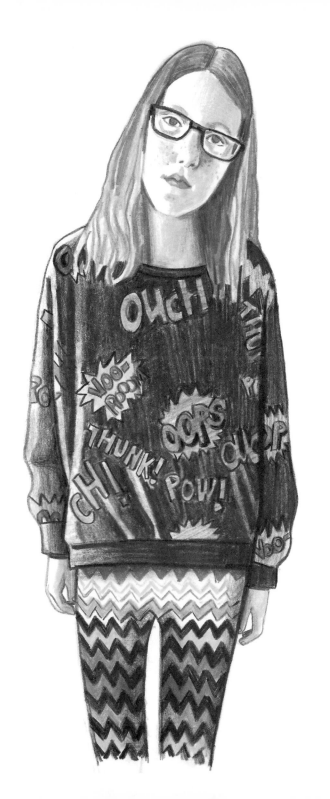

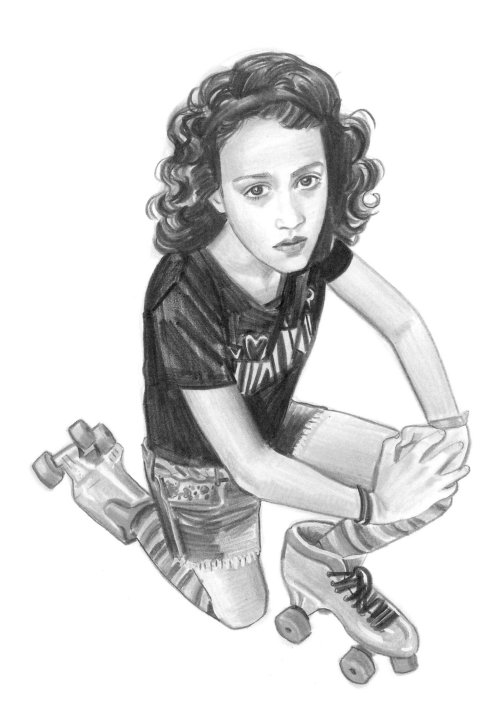

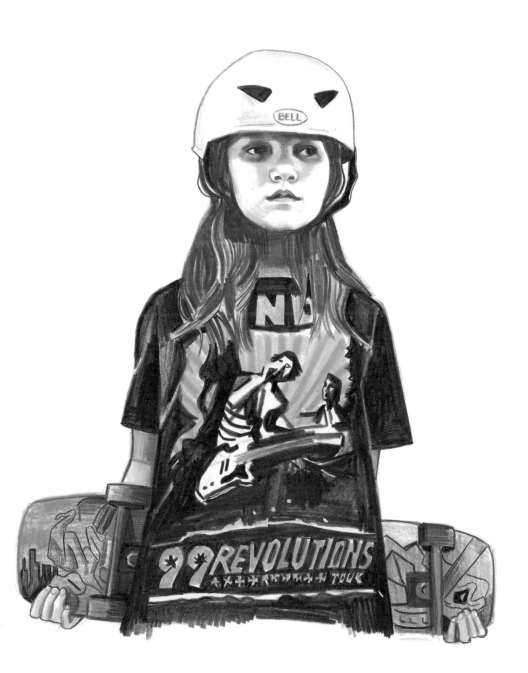

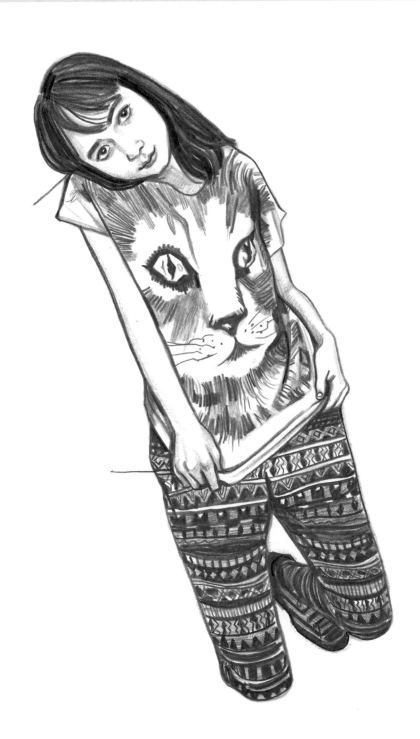

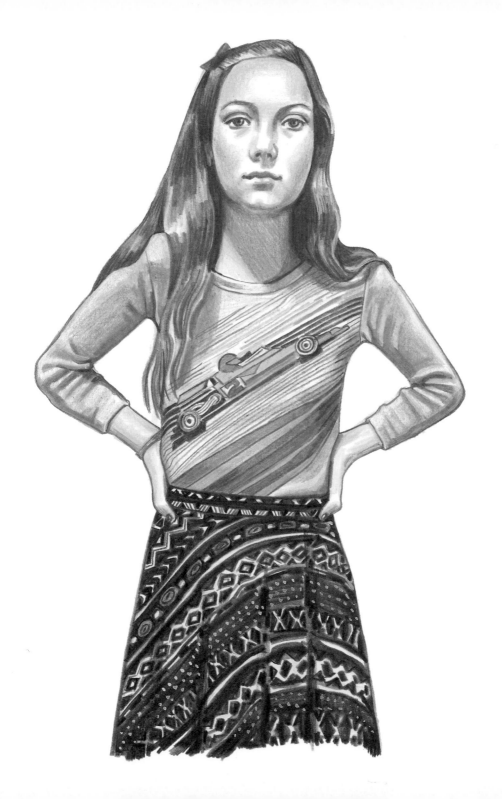

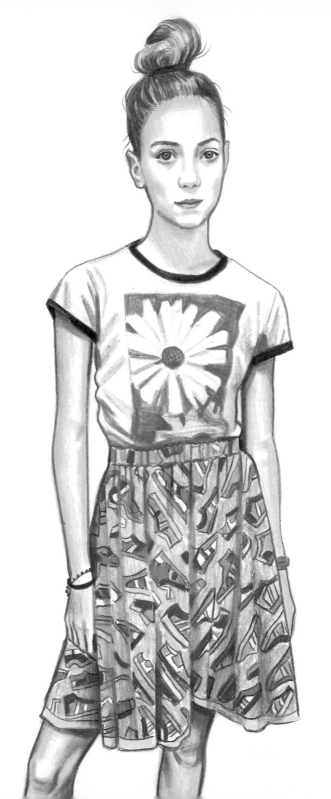

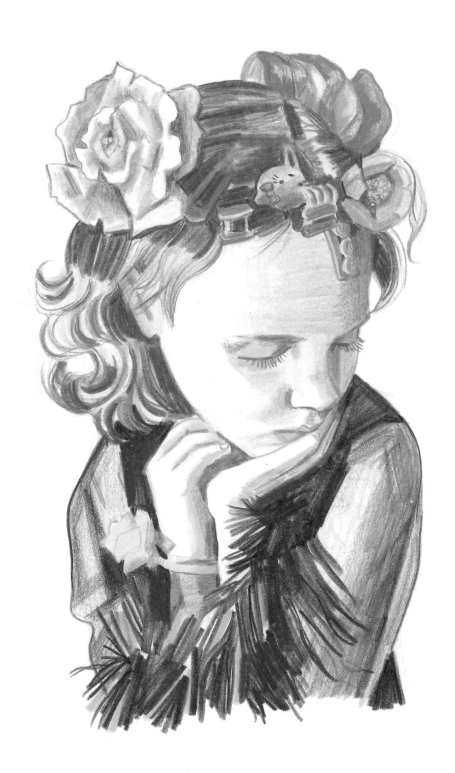

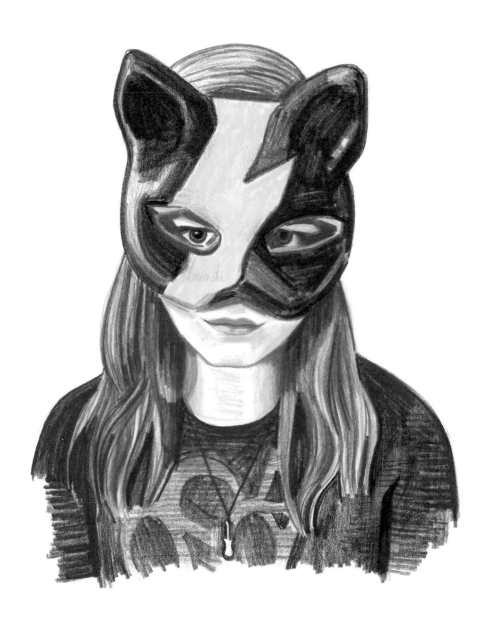

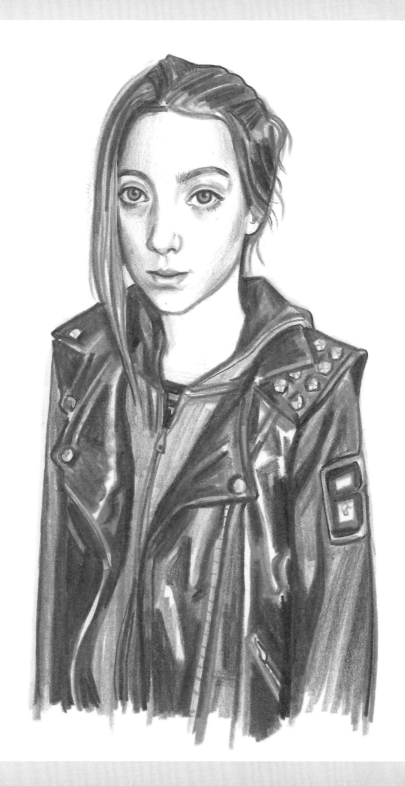

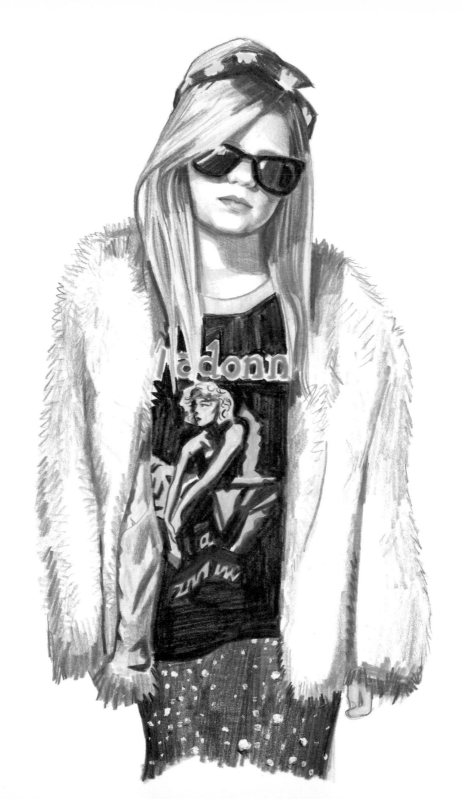

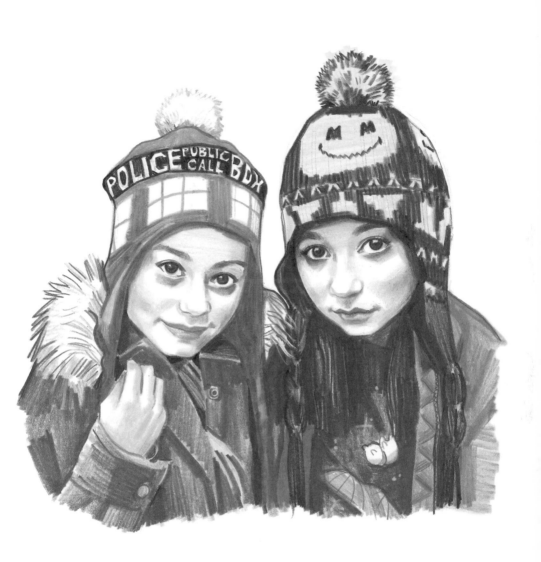

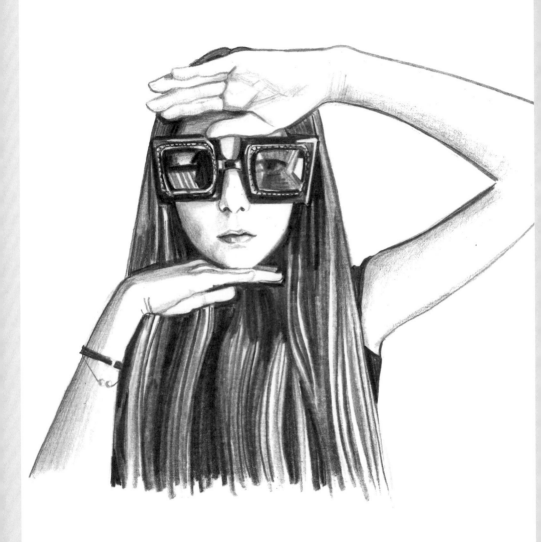

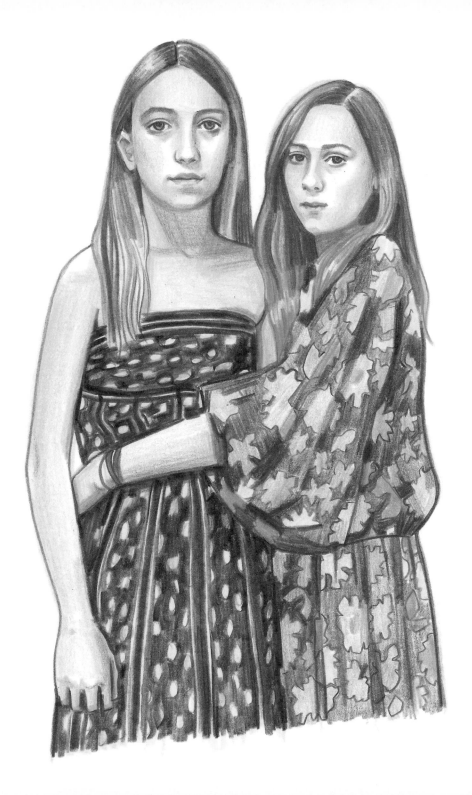

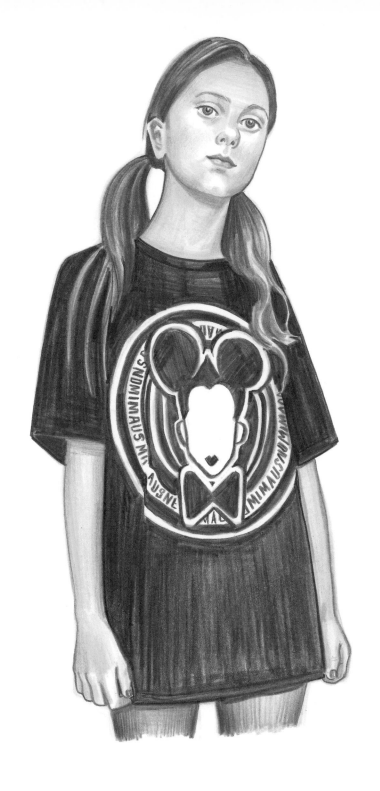

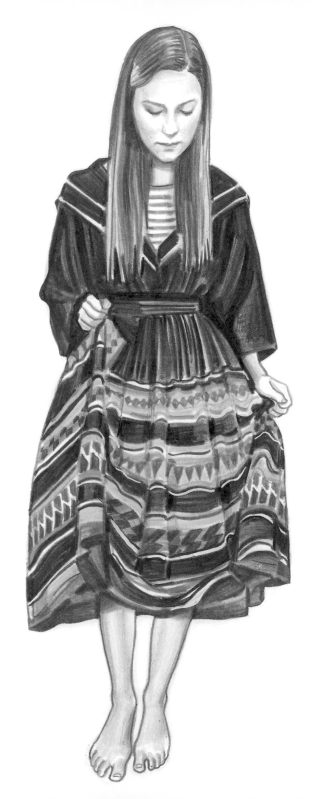

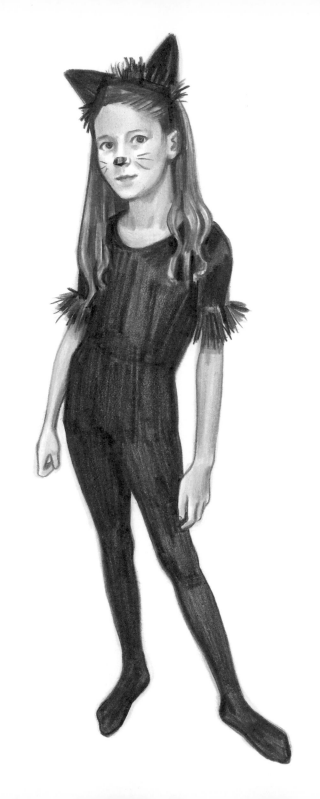

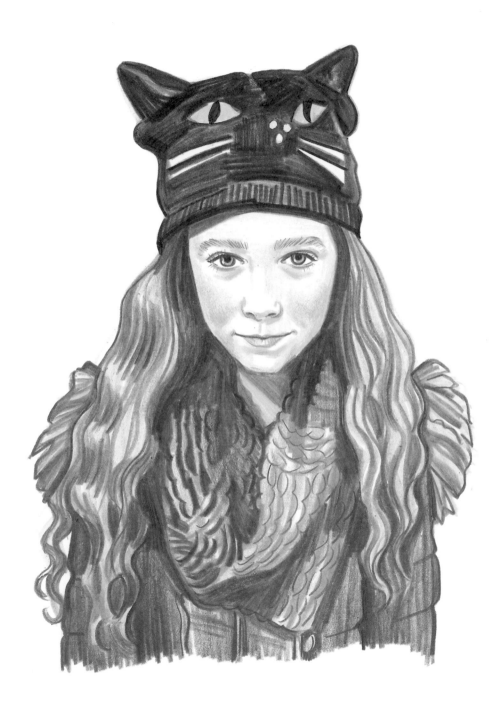

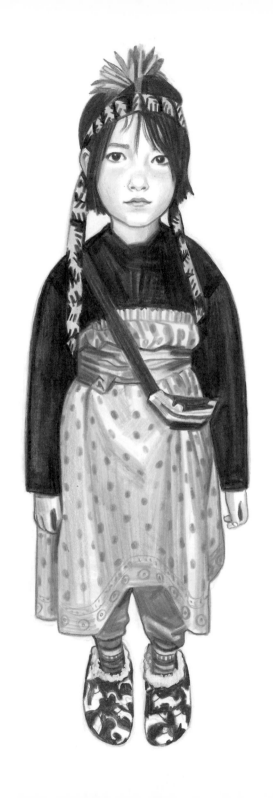

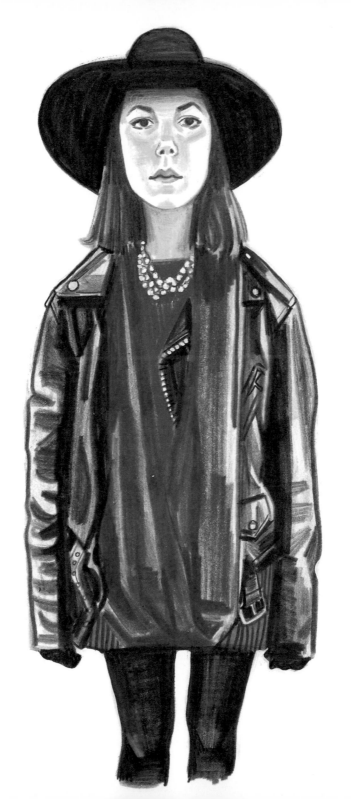

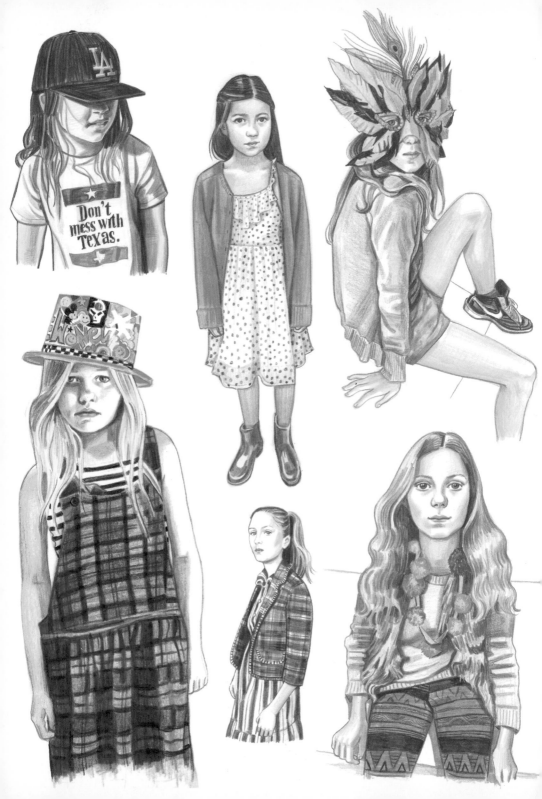

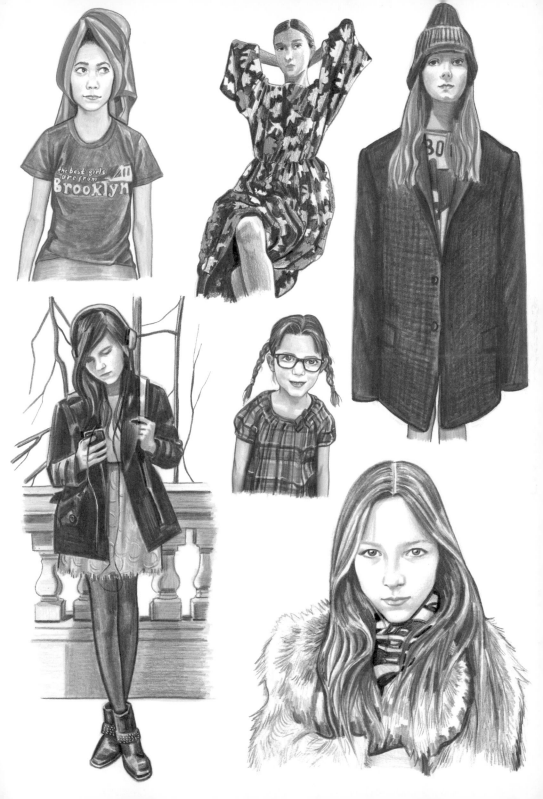

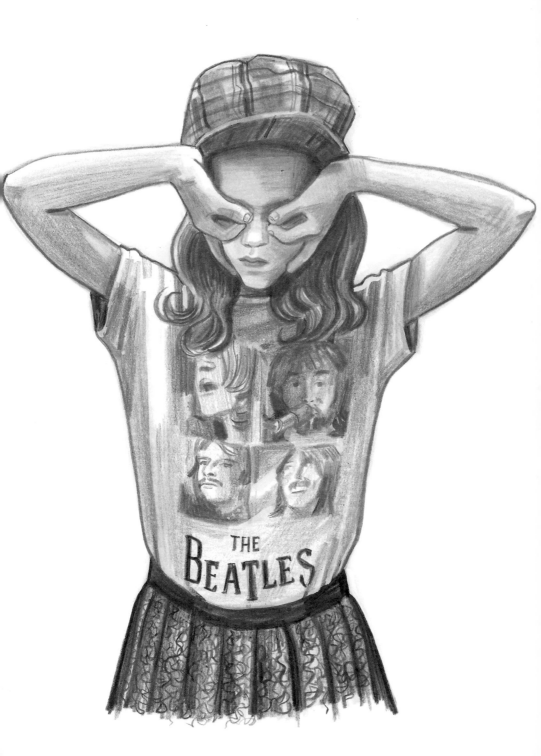

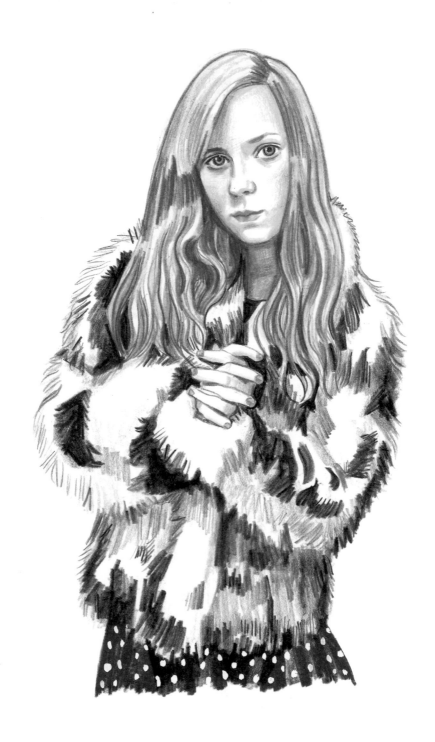

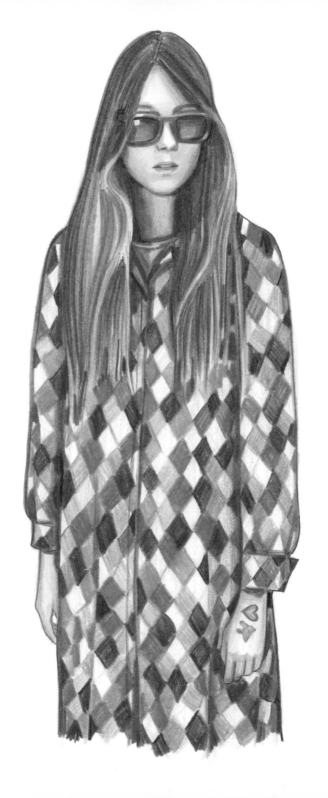

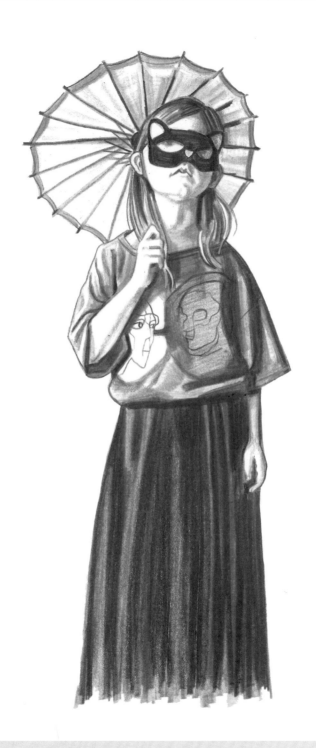

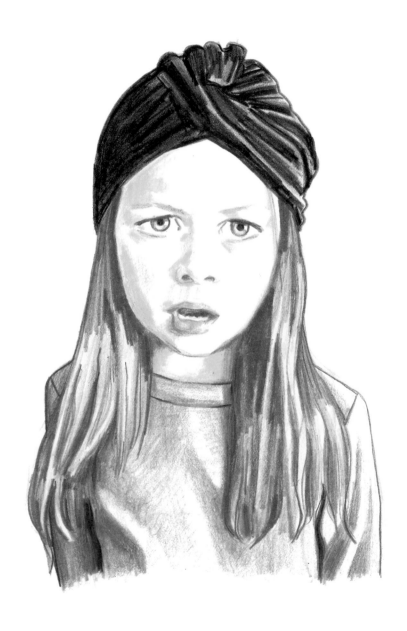

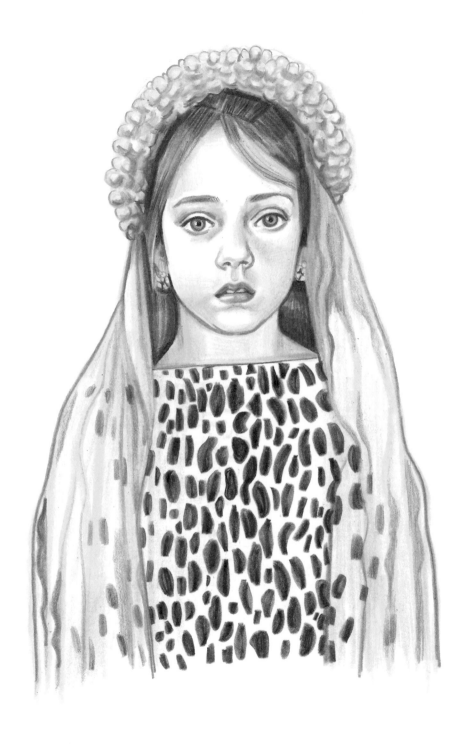

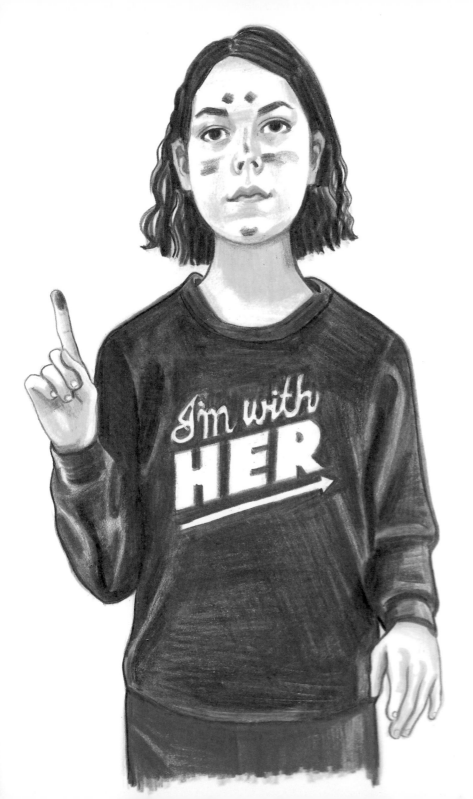

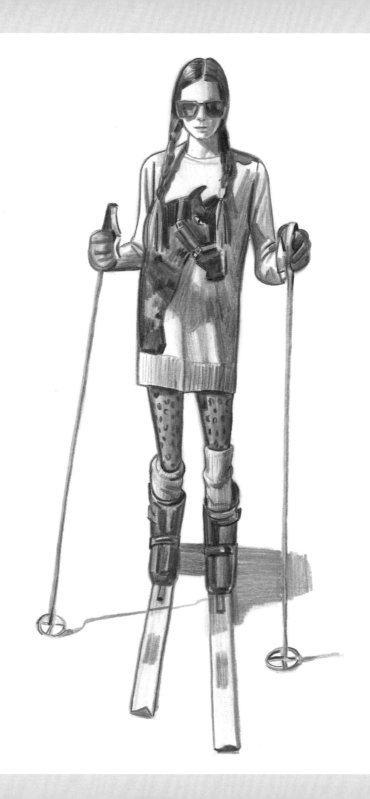

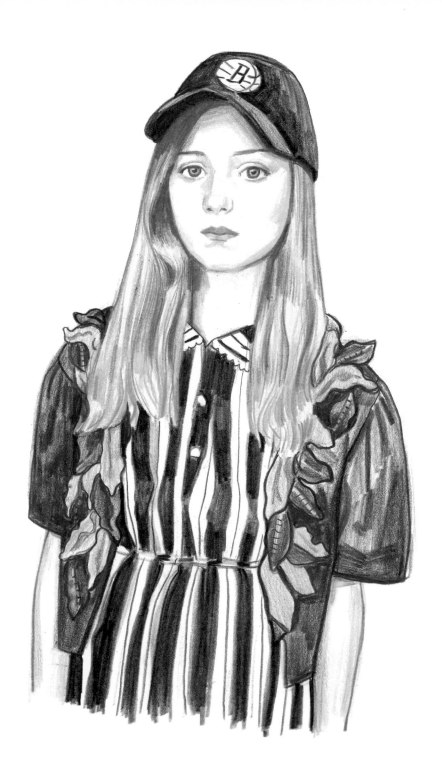

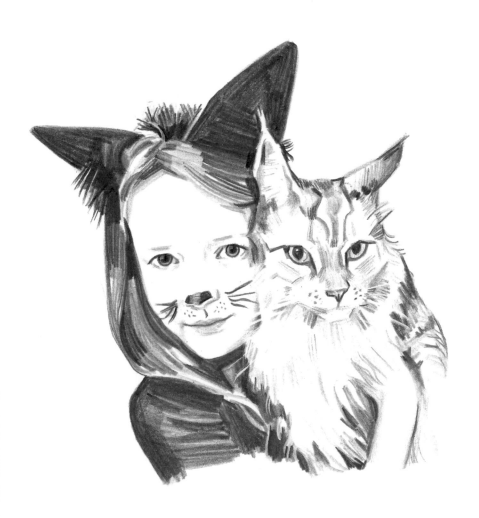

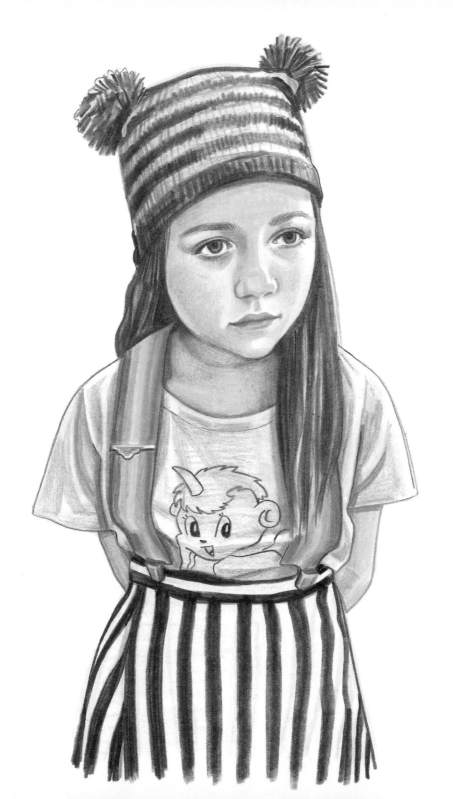

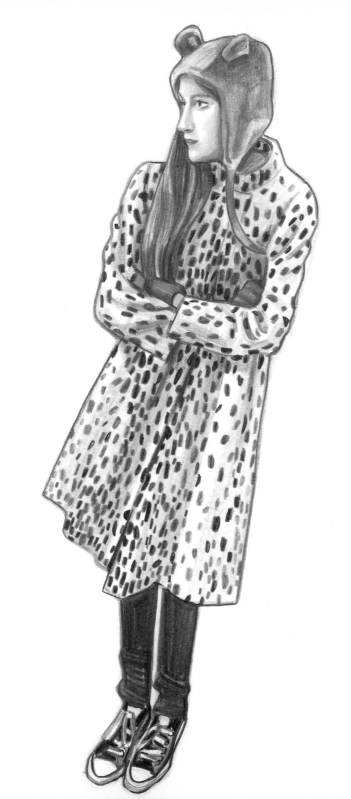

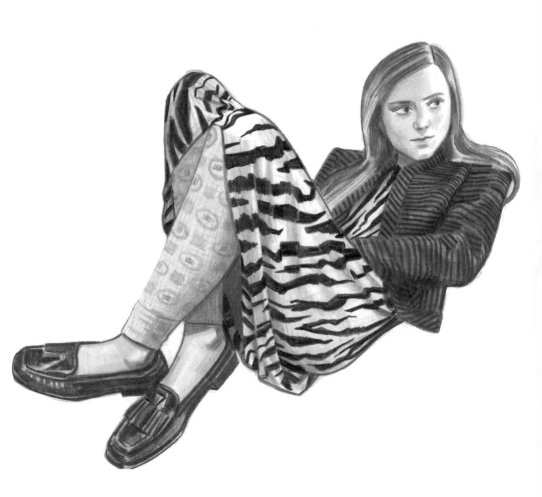

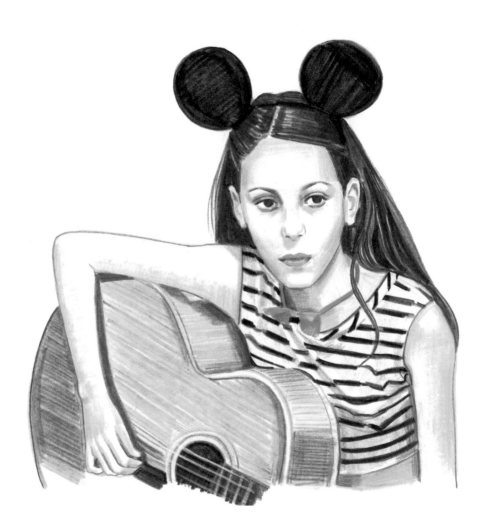

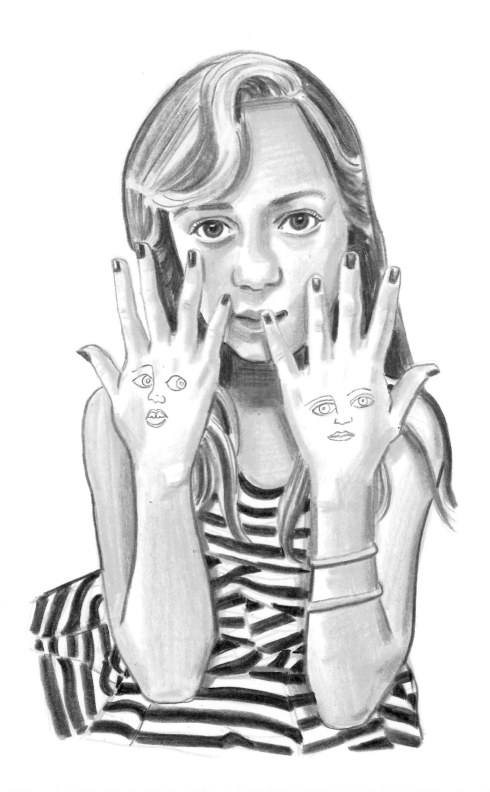

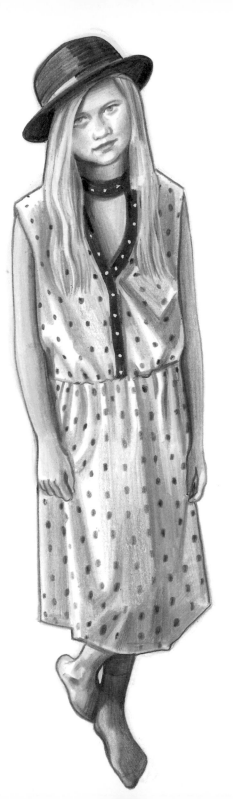

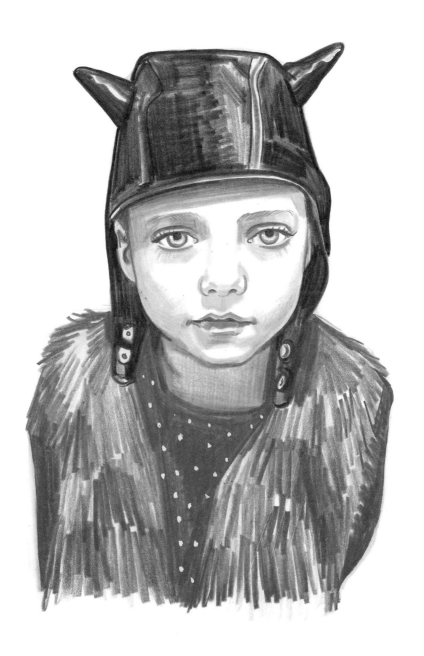

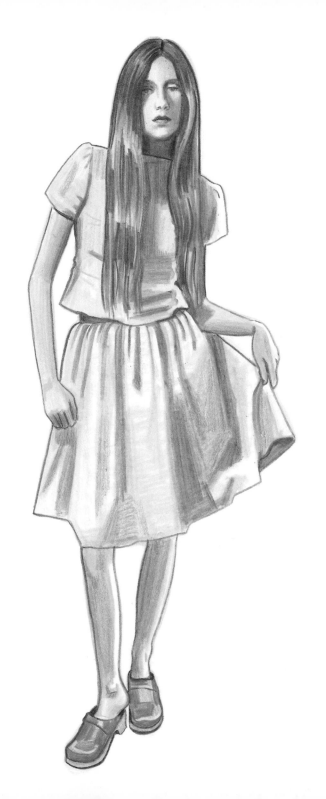

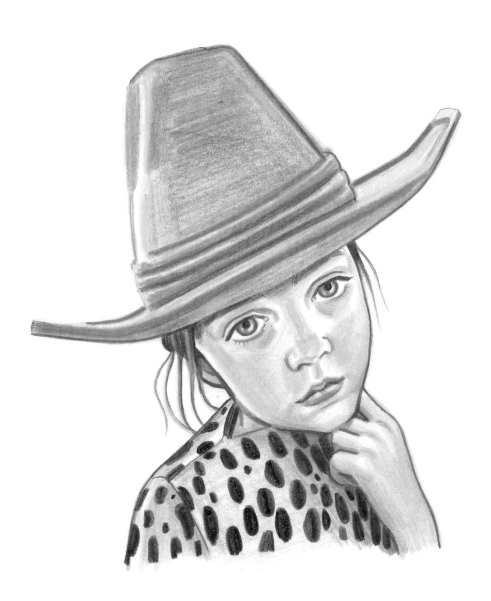

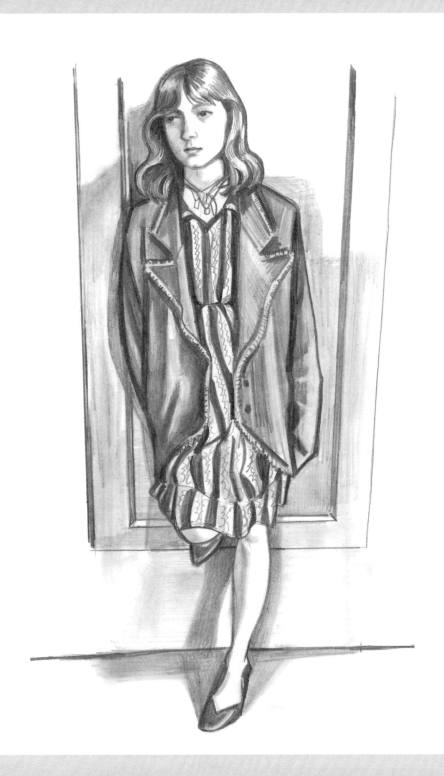

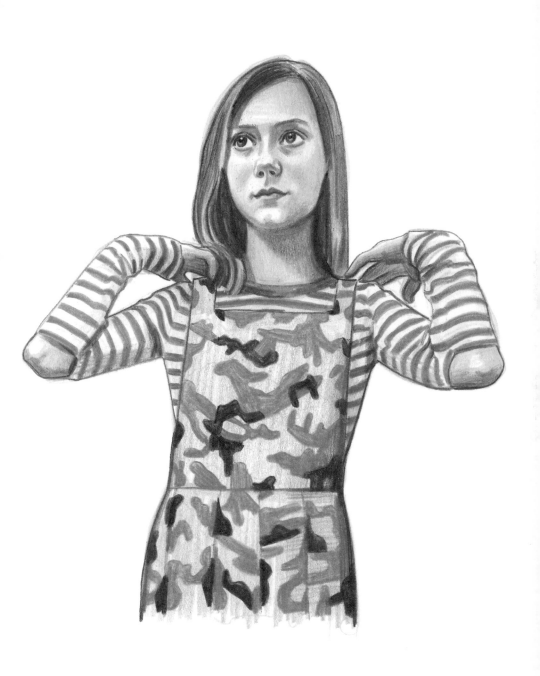

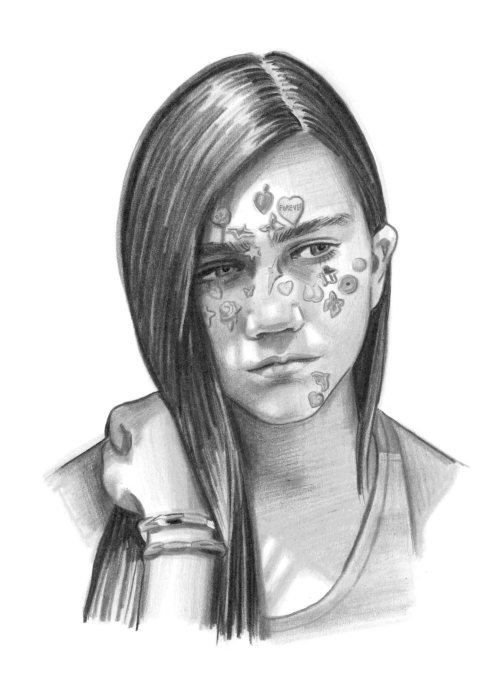

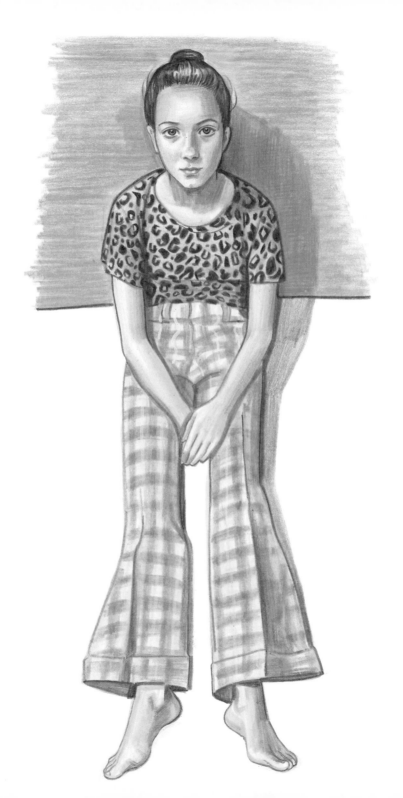

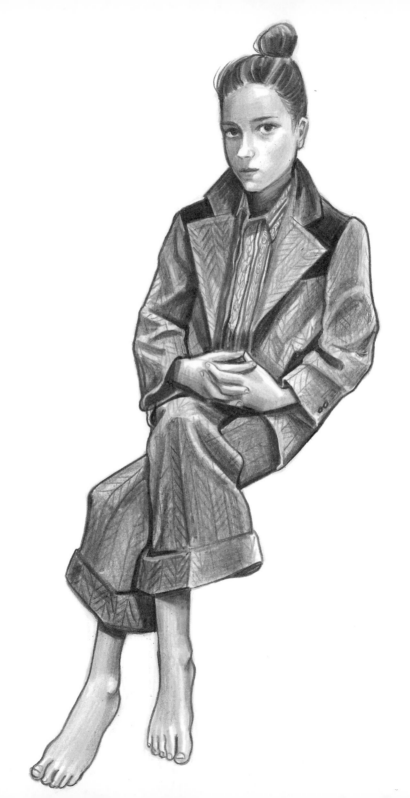

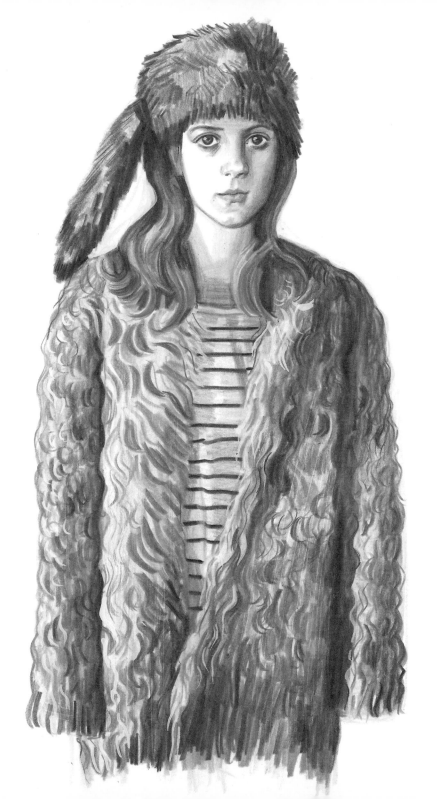

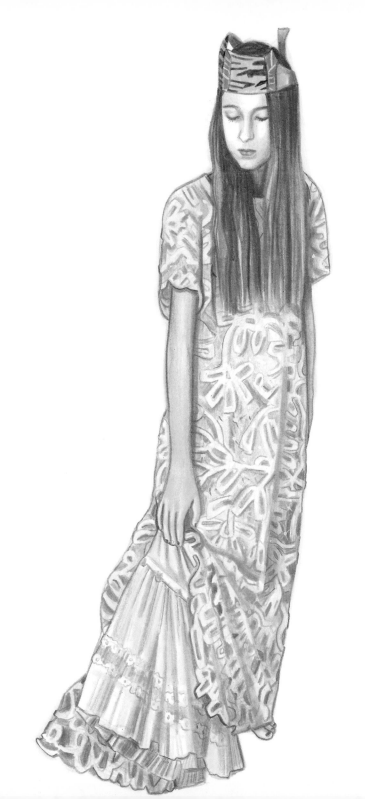

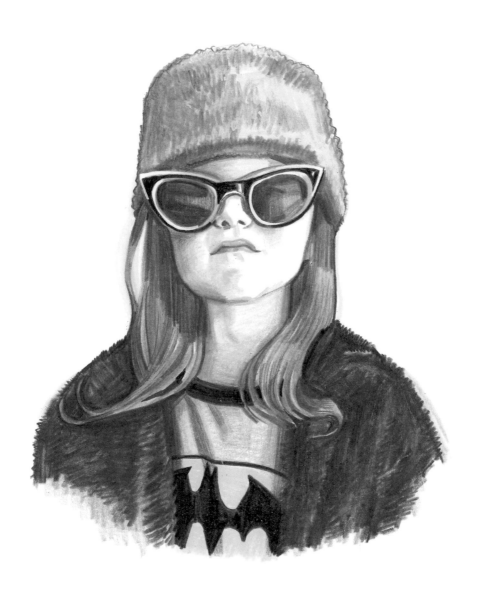

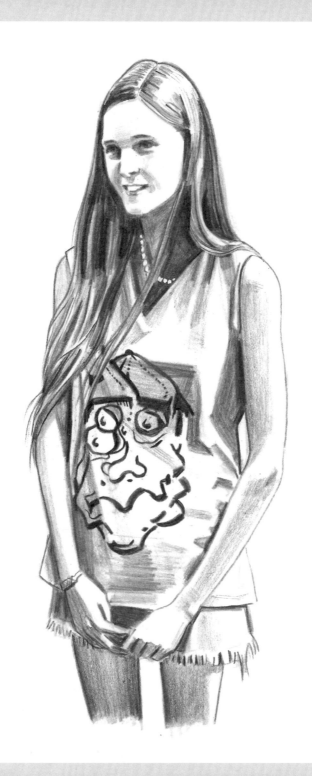

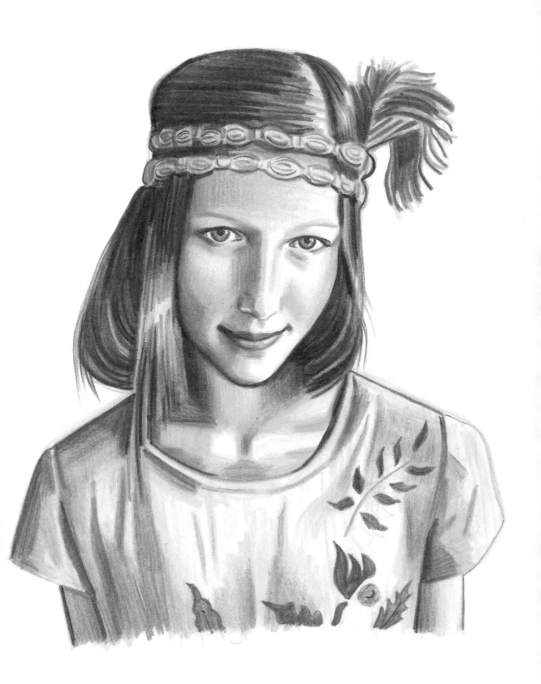

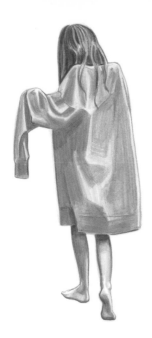

AFTERWORD
BY JENNY WILLIAMS

What My Daughter Wore began as a blog with the simple mandate described in its subtitle, to document "the sartorial decisions of my daughter, her big brothers, and their friends." A collection of pencil drawings, it captures the children in my orbit who inspire me every day with their attitude and personal style. From the beginning, it has featured boys and girls, from toddlers to college students, wearing everything from hand-me-downs to fancy dress to Halloween costumes.

Over time, however, it became clear that one story was being told above all the others: that of a girl in the transitional years between her early childhood and late teens. Reviewing the project for this book, I was drawn to those images that best conveyed the character and transgressiveness of that fleeting chapter in a girl's life. Observing my 12-year-old daughter and her peers—and remembering the same era in my own life—I was moved by how strongly, at that age, the desire to be unique still trumps the instinct to conform.

When I was in middle school, I dressed like a Victorian orphan. My best friend and I expressed our contempt for popular culture and asserted our status as outsiders by rejecting the Gloria Vanderbilt jeans and feathered hair of our peers in favor of the tattered lace and corkscrew curls of the fallen Sara Crewe. What we wore was of a piece with the drawings we made, the poetry we wrote, and the radio plays we recorded: all were expressions

of our passions, our fluctuating overconfidence and insecurity, and our boundless creativity.

The girls that I have drawn here may not go so far as to live part-time in a bygone era, but each finds her own particular way to define herself and assert her individuality through what she chooses to wear. My daughter currently favors her brothers' outgrown vintage collared shirts, and tube socks with skirts. Others dress to exhibit their allegiance to a particular cultural phenomenon (I know more than my share of young Comic-Con attendees), or their love of any hood or hat with ears. I have drawn outfits that were accessorized with the help of glue guns, construction paper, glitter, stickers, Sharpie, leaves and flowers, iron-on patches, safety pins, and yarn. I have discovered that it is a rare girl who doesn't have a rubber hair band around her wrist that can serve multiple purposes.

Inevitably, concern for trends and uniformity creeps in, with a growing awareness of the opinions and judgment of others. I rolled my eyes at Victoriana by ninth grade, and lately I notice that my daughter is likely to choose a standard pair of skinny jeans over the Brady Bunch-era thrift store pants she used to wear. This book documents an in-between moment in a girl's life filled with wildness, introspection, and joy, which is over (as all of childhood is) much too soon.

ACKNOWLEDGMENTS

Thank you to the following people, without whom this book
would not have been possible: first and foremost, to all of the creative and beautiful girls
who have been my collaborators on this project, in particular my two
original muses, Clementine and Langston. To Paco and Whit,
the best sons in the world. To the inspiring Olivia Bee. At powerHouse,
thank you to Craig Cohen, Wes Del Val for his guidance and good taste, and
Kristi Norgaard for her beautiful and fun design. To Erica Silverman for
believing in the project. To Gayle Smith for her vision and advice, and to James Cathcart
for being an invaluable sounding board. Finally, thank you always to
my husband David Clark, and our loving and supportive family and friends.

WHAT MY DAUGHTER WORE

Illustrations © 2014 Jennifer Williams
Introduction © 2014 Olivia Bee

Published in the United States by powerHouse Books,
a division of powerHouse Cultural Entertainment, Inc.
37 Main Street, Brooklyn, NY 11201-1021
telephone 212.604.9074, fax 212.366.5247
e-mail: info@powerHouseBooks.com
website: www.powerHouseBooks.com

First edition, 2014

Library of Congress Control Number: 2014943719

ISBN 978-1-57687-726-5

Design by Kristi Norgaard

Printed and bound through Asia Pacific Offset

10 9 8 7 6 5 4 3 2 1

Printed and bound in China